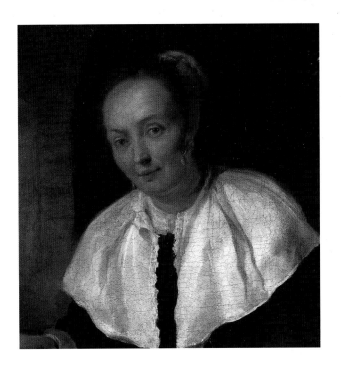

Pleasures of Collecting:
Part I, Renaissance to Impressionist Masterpieces

Peter C. Sutton
Executive Director
Bruce Museum of Arts and Science

Jennifer Ambrose
Hollister Sturges III Resident Intern
Bruce Museum of Arts and Science

September 21, 2002 through January 5, 2003

Bruce Museum of Arts and Science
Greenwich, Connecticut

The exhibition and its catalogue
are generously underwritten by

JPMorgan Private Bank

Susan E. Lynch
Greta R. Pofcher

with support from the
Connecticut
Commision on the Arts

Connecticut
Commission on the Arts

Director's Acknowledgments

Shows of art from private collections incur the greatest debts of gratitude since in the case of each work of art an individual has sacrificed the pleasure of its presence in their private home for the enjoyment of the public. To our many lenders, I thank you from the bottom of my heart. I also wish to thank our corporate sponsors, J P Morgan Private Bank, for their generous underwriting of both Part I and Part II of the *Pleasures of Collecting*. We are delighted by their ongoing support and involvement with the Bruce Museum. We also are grateful to the Connecticut Commission on the Arts for their donation to the costs of this project. We thank Chuck Royce for his far-sighted support of the entire exhibition program. And an especially warm expression of gratitude is extended to Susan Lynch and Greta Pofcher for their wonderfully generous and spontaneous support of the show. Heartfelt thanks to two of the finest ladies in Greenwich! It would not have been possible without you.

We also owe thanks to scores of people who advised on the whereabouts of pictures and made introductions so that a relatively new and unknown Director could visit the collectors who own these marvelous works of art. Special thanks for advice and assistance of various sorts go out to J. Patrick Cooney, Ann Guité, Sophia James, Rachel Mauro, Jack Kilgore, Otto Naumann, Richard Feigen, John Hand, Polly Sartori and Nicolas Hall.

In compiling the catalogue I received the most reliable and cheerful assistance from my co-author, the Hollister Sturges Intern, Jennifer Ambrose. The catalogue was edited with admirable care by Martha Zoubek and Susan Larkin and proofread by Joan Antell. The lovely design for the book is the creation of our perennially creative Director of Exhibitions, Anne von Stuelpnagel. Photography was supplied by the indefatigable Paul Mutino. Finally I wish to thank the staff of the Frick Art Reference Library, the country's pre-eminent art historical resource, for making our research possible.

Peter C. Sutton
Executive Director, Bruce Museum of Arts and Science

Pleasures of Collecting:
Part I, Renaissance to Impressionist Masterpieces

Peter C. Sutton

Private collectors have always been in the advanced guard. Some work with museum directors, curators, art advisors or favored dealers, but many collect on their own or with loved ones, identifying neglected areas of importance in the history of art, recognizing emerging artists, or commissioning works from living artists. For many, collecting is a life-enhancing experience, not merely because it satisfies an appetite for possession but also because it offers aesthetic, intellectual and emotional insights, repaying the collector with lifelong learning and the recurring pleasure of discovery. Collecting can be a form of personal education, an extension course in advanced looking; art at its best, after all, captures the essence of human experience and becomes a repository of all that is most eloquent in civilization. Collecting can also be a component of and catalyst for social activity, since it is rarely a solitary pursuit. Unlike a visit to the symphony, opera, ballet or even the movies, trips to museums, galleries, dealers and auction viewings do not require one to be silent or sit still; conversation complements, even enriches, the visual experience. Personally held art is also part of what in

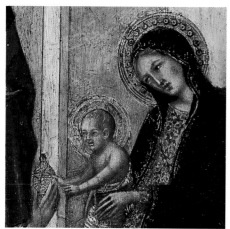

today's jargon is commonly called "lifestyle," by which we mean the setting, surroundings and enveloping context in which an individual chooses to live. Great art improves one's environment, be it personal, domestic, social or professional. Of course, for some collectors art is also an investment; however, the best and most successful collectors realize that great art pays dividends every day that are part not merely of a diversified portfolio but also of a balanced and fulfilling life.

Although they rarely have the scholarly resources of a museum or university, private collectors often make a substantial personal commitment to their collecting. They must do their homework and develop their connoisseurship to determine an object's quality, authenticity and condition. At first pass, the notion of a connoisseur, given the word's French origins and aristocratic associations with minute and ineffable discernment, might seem stuffy, recondite and old-fashioned. But unlike a degree in art history, connoisseurship is a skill open to all who are willing to take the time to look and compare, to develop a visual memory, and to refine what is known as an "eye" – the ability to recognize an important work of art and the superiority of one example over another. Successful collectors also pay close attention to the art market, since unlike curators or other institutional buyers, they commit their own money. This naturally focuses one's attention, while serving an essential

public service in establishing market value and determining what the "priceless" is actually worth.

Exhibitions of privately owned art, drawn from local collections, spanning the centuries, and often assembled on a vast scale, were once the mainstay of exhibition halls and museums. One need only invoke the history of huge shows like the *Treasures of Great Britain* exhibition held in Manchester in 1857 or those comprised of literally hundreds of paintings from country homes held annually in the nineteenth and early twentieth centuries by the Royal Academy or the Burlington Fine Arts Club in London, when both the art and country gentry needed an airing. In our own country, monumental, sprawling events like the Hudson-Fulton exhibition held at the Metropolitan Museum of Art in 1909, or the *omnium gatherum* exhibition mounted at the World's Fair in New York in 1939 brought truckloads of paintings together from private hands. Today such shows, though featuring some of the greatest works of Western art, seem like ponderous pictorial dinosaurs; museum professionals and their audiences now favor leaner, more tightly structured and conceived monographic or thematic exhibitions. And yet there is still much to be learned from periodically casting the net more broadly. Shows of art from private collections reveal many honorable and intriguing traditions and can identify significant patterns of private taste that frequently move in advance of institutional and museum acquisitions.

The Bruce Museum is an ideal place to mount a survey of private collecting because it serves a regional community where a remarkable number of distinguished collectors reside. Although centered on a township of barely 60,000 inhabitants, greater Greenwich is one of the most important centers of private art collecting in the United States. From the holdings of area collectors one can assemble a survey of Western art from the Renaissance to the present that would be the envy of many museums. In no small measure this is because of our proximity to New York City, now unquestionably the capital of the art world, and one of the greatest sources of the supply, distribution and inspiration of art. This concentration also speaks to the well-educated, cosmopolitan and affluent profile of our local citizenry. Yet while financial wherewithal may be a prerequisite of collecting art at a high level, it is not a sufficient condition; witness the many wealthy but culturally malnourished suburbs in America. Rather, this concentration seems to reflect the sophistication of an informed and enthusiastic community of collectors who appreciate the special joy and gratification that arise from a shared appreciation of art. Space constraints at the museum have dictated that we restrict the show to Western paintings, drawings and one (albeit exceptional) sculpture, but one could as readily have expanded it to include decorative arts as well as non-Western art. So extensive are the private reserves

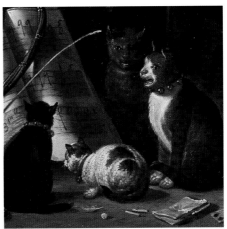

that we decided to mount the show in two parts: the first focusing on art before about 1900, the second spotlighting twentieth century and contemporary art. As in most communities today, there are more collectors of recent art and art by living artists than of works by earlier masters.

Though not so numerous as later art, examples of fifteenth- and sixteenth-century Italian Renaissance paintings have been collected in the area, including works by accomplished but lesser known artists like Bertolo di Fredi, Battista Dossi, and Georgio Vasari. To compare the images of the *Adoration of the Magi* by Bertolo di Fredi and by Giorgio Vasari is to understand the range of the achievement of the Renaissance. The former represents pioneering early efforts to depart from the conventions of iconic medieval imagery in order to depict the miracle of the Christian birth in a more clearly defined spatial context with more naturalistically defined figures. The latter represents the fulfillment of the Renaissance, when hieratic subject matter was represented in an increasingly formalized and Mannerist idiom. Given the rarity of early Italian art, it is a small wonder that such works are available at all, especially since they once were some of the most sought-after paintings; witness the collections assembled in the nineteenth and early twentieth centuries, such as the Jarvis Collection at Yale University Art Gallery in New Haven and the John G. Johnson Collection in the Philadelphia Museum of Art. In imitation of Medici princes, early-twentieth-

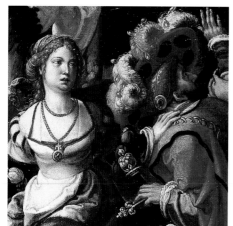

century captains of industry and finance once surrounded themselves with tapestries and gold-ground paintings (the Bertolo di Fredi was once owned by J.P. Morgan). Today, however, most American collectors prefer less palatial if hardly understated domestic settings.

Many are drawn to Northern Baroque paintings, specifically seventeenth-century Dutch art. While one encounters a few Northern Renaissance and Mannerist works (for example, the paintings attributed to Pieter Coecke van Aelst and to a mannerist follower of Joos van Cleve), more plentiful are Dutch paintings of the following century. For at least two centuries, there has been a love affair between the American entrepreneur and Dutch art, in part because of its naturalism, everyday subject matter and emphasis on the painter's craft. These qualities have often been interpreted as expressions of the Dutchman's practicality, love of commerce, tolerance and commitment to democratic values – all seemingly foretelling American ideals. There are fine examples locally of Dutch landscapes that celebrate the empirical observation of nature and its creative presentation. We offer, for example, a bracing image of the wind-blown shore of the Zuider Zee by Jacob van Ruisdael, an intimate wooded landscape by his pupil, Meindert Hobbema, and a subtle symphony on the hues, from tawny to silvery gray, in a beach scene by Simon de Vlieger, who along with Ruisdael was one of

the originators of this perennially popular, and for our community, topical theme.

Another strength of local collections is the Dutch genre scene or image of everyday life. We display fine examples by, among others, the great comedian of Dutch painting, Jan Steen. They range from the latter's frisky low-life tavern scene, to the powdered wigs and refinements of Adriaen van der Werff, who announces a move to more international, and above all, French taste that appeared when Holland was overrun by Louis XIV's troops in 1672. A particularly fine and characteristic example of the Dutch genre tradition is the amusing and animated *Tavern Scene* by Cornelis Bega. Descended from Flemish sixteenth-century images by the peasant painter, Pieter Brueghel the Elder, and his followers, it depicts a rowdy scene of merrymakers, albeit revelers that have become more respectable than their ancestors. Important precursors include Bega's teacher, Adrian van Ostade and Adriaen Brouwer. Yet the scene, for all its choreographed rowdiness, demonstrates an extraordinary mastery of technique, involving fine draftsmanship and detailed execution, as well as a creative interpretation of one of the low-life tradition's most time-honored subjects. While Bega is now represented in the J. Paul Getty Museum and other important collecting institutions, he remains relatively unknown to museumgoers.

The depths of the ranks of Dutch artists have often been plumbed by private collectors before institutions. Among the important and undervalued Dutch genre painters, for example, one must count Adriaen van de Venne, whose images in *grisaille* and *brunaille*, often destined as models for prints and inscribed with moralizing messages, are some of the most representative examples of Dutch culture. The Dutch were among the first to celebrate the charm of common, quotidian activities, at a time when the depiction of religious, historical and allegorical themes were regarded as the highest ideal. Whether gamboling peasants by Adriaen van de Venne, carousing tavern dwellers by Steen or Bega, a pretty fishwife by Gabriel Metsu, a greengrocer offering his produce by the Dutch-Italianate painter, Jan Baptist Weenix, or high life by Adriaen van der Werff, they offer a surprisingly broad cross-section of society.

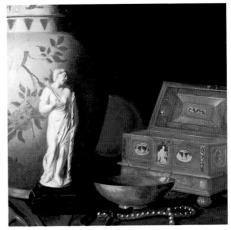

Still life is also represented in local collections; see as examples the early work by the important and gifted woman painter, Rachel Ruysch, and the *trompe l'oeil* by Roestraten here on view. While Dutch art is usually associated with secular subject matter, we also offer here religious images by Jan van Bijlert and Thomas de Keyser, as well as Frans van Mieris's depiction of the classical tale of the *Death of Lucretia*. The highly refined *fijnschilder* style was perfected in the university town of Leiden by van Mieris and his teacher Gerard Dou, and brought the art of painting to the most minutely detailed state of finish and polish ever

attained. Very expensive in their own day and eagerly collected throughout the eighteenth and early nineteenth centuries, *fijnschilder* painting fell out of favor with the rise of Impressionism's more painterly manner and only became desirable again among collectors in the last third of the twentieth century. Flemish Baroque painting is less commonly encountered in local collections, but the American taste for Peter Paul Rubens's oil sketches will be the subject of a show at the Bruce in 2004.

Eighteenth-century French painting is not common in area collections but there is a pair of exceptionally fine landscapes by the charming French master, Jean Pillement, as well as an oil sketch for one of François Boucher's decorations for the Dauphine's apartments in Versailles. We also encounter here a fresh little oil sketch of a young girl by the great eighteenth-century English portrait painter and satirist, William Hogarth. Here too we have an important portrait of one of the painter's patrons by the English Victorian artist, George Frederic Watts.

More numerous are the works of nineteenth-century French masters. These include examples by the academic master *par excellence*, Adolphe William Bouguereau, as well as lesser-known and even anonymous masters of merit. An especially ravishing little painting of an elegant lady reading by Giovanni Boldini attests to the ongoing popularity of high-life genre scenes. Once scorned by the

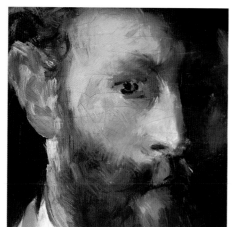

champions of Impressionism and modern art, Bouguereau and Boldini have been rediscovered in recent decades and once again are darlings of the salesrooms. Barbizon painting, formerly the mainstay of New England and especially Boston collectors, is now little in evidence, although the great Realist, Gustave Courbet, is avidly collected but unfortunately could not be represented in this show. French Impressionism retains its fanatical popularity with early twenty-first century audiences. The divided light and color, the loaded brush, atmospherics and heightened tonality, as well as the themes of those paintings (often rural or suburban leisure), continue to enchant modern collectors even as the supplies of this type of art dwindle and prices rise ever higher. Excellent landscapes by Claude Monet, Camille Pissarro, Gustave Caillebotte, and Henri Le Sidaner grace area collectors' walls. Here too is a magnificent self-portrait by the pioneer of Impressionism, Edouard Manet, an intimate figure study by Berthe Morisot as well as drawings by Edgar Degas and Vincent van Gogh. A highlight of the present show is *Landscape, Island of La Grande-Jatte* of 1884 (illustrated on the cover) by the Pointillist Georges Seurat, which depicts the same view as the artist's most famous painting *Un Dimanche a la Grand-Jatte*, preserved in The Art Institute of Chicago. While the latter represents the island in the Seine crowded with Sunday visitors, the present work shows the luminous serenity of

the sparsely populated landscape on a weekday. Finally, although we have not attempted a comprehensive survey of sculpture in area collections, the rarity and importance of Edgar Degas's *Little Fourteen-Year-Old Dancer* inspired us to make an exception. It is not an exaggeration to say that when the prototype of this piece was first exhibited, it created a stir that changed the course of the history of sculpture.

It is to be expected that there is a keen local interest in American painting, especially that of the nineteenth century. We have works by the Connecticut colonial portraitist, Ralph Earl, as well as one of the better likenesses of the father of our country by the talented Rembrandt Peale. Far more common are landscapes. A fine image of *Newbury Marshes* by Martin Johnson Heade is a classic Luminist landscape, and a work by Alfred Thompson Bricher offers a glimpse of a refreshing and blissfully underpopulated beach. A special strength locally is the work of the Hudson River School painter, Jasper Cropsey, whose descendants reside in the area. Also predictably strong are the works of the American Impressionists from Greenwich's own Cos Cob art colony, Childe Hassam and Elmer MacRae. One of the latest works in the present show and a relatively recent acquisition by the collector is Willard Leroy Metcalf's *The Violets*, a charmingly memorable picture that proves that alert collectors can still make astute purchases.

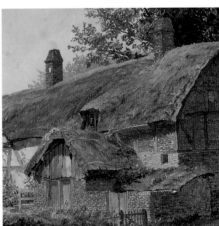

As the diversity of the paintings included in the present show attest, and Part II of the exhibition devoted to Modern and Contemporary art will affirm, there is no typical greater Greenwich collector. Given the fact that many local residents' careers are in investments and financial services, some share similar backgrounds, but their tastes are surprisingly varied. Here too are retired industrialists, the CEOs of companies, as well as some of New York's most successful art dealers, who have taken home some of their finest stock to enjoy in their own private collections. Yet most collectors lend anonymously, concealing their identities even to their peers. Only a half-century ago, lenders to exhibitions made a point of proudly identifying themselves in the credit line to catalogues and labels to shows, but today art may constitute a larger portion of a collector's personal assets and a desire for privacy often inspires greater discretion. We are all the more grateful, therefore, to the collectors for sharing these valuable and rare objects with the public and for permitting us to temporarily enjoy their uplifting effect.

Plates

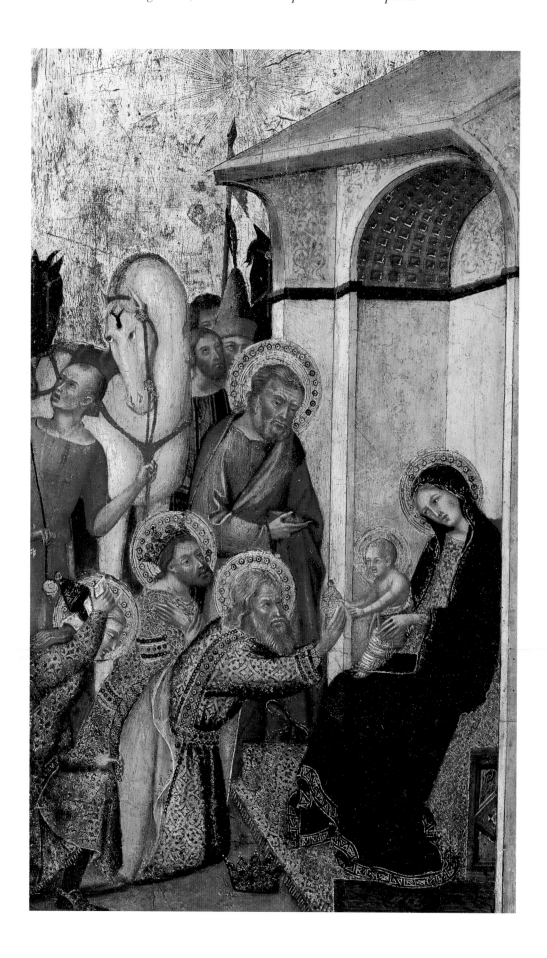

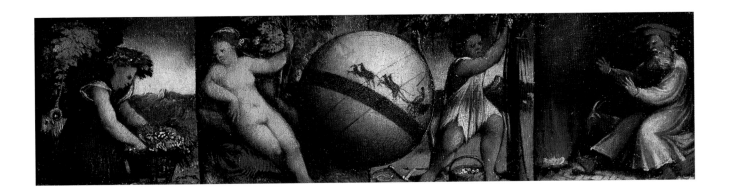

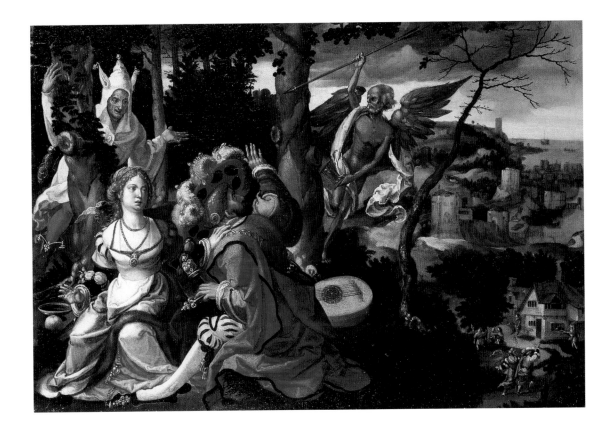

Battista Dossi (Ferrara c.1495–1548 Ferrara)
The Four Seasons with Signs of the Zodiac
Oil on cedar panel
3 x 10 1/2 in. (7.7 x 26.5 cm)
Collection Richard L. Feigen, New York

Bartolo di Fredi (died 1410 Siena)
Adoration of the Magi, c.1375
Oil on panel
14 x 8 3/4 in. (35 x 21.9 cm)
The Phillips Family Collection

Attributed to Pieter Coecke van Aelst (Aelst 1502–
1550 Brussels)
Lovers Surprised by a Fool and Death, c.1530
Oil on panel
14 7/8 x 21 1/8 in. (37.8 x 53.7 cm)
Private Collection

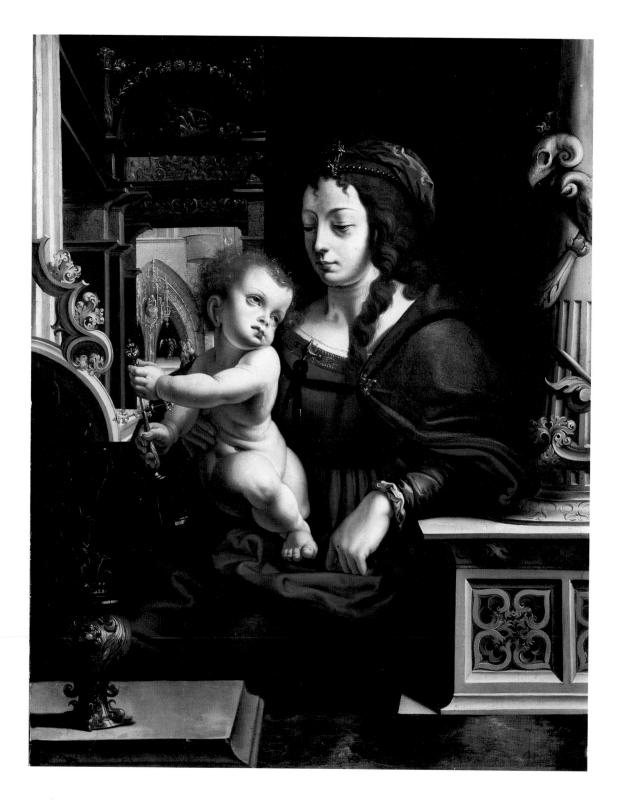

Follower of Joos van Cleve (Cleves c.1485–1540/41 Antwerp)
Madonna and Child
Oil on panel
29 1/2 x 22 1/2 in. (75 x 57 cm)
Collection Seena and Arnold J. Davis

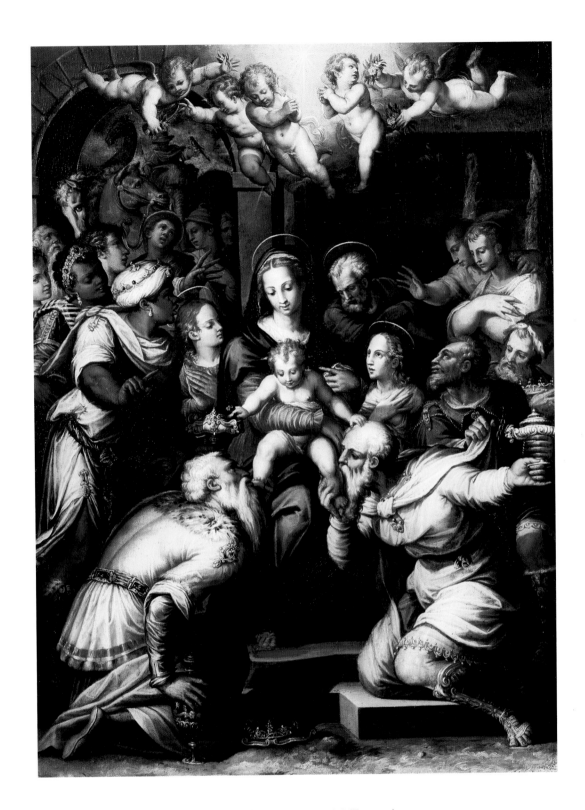

Giorgio Vasari (Arezzo 1511–1574 Florence)
Adoration of the Magi, c.1566
Oil on panel
25 5/8 x 18 7/8 in. (65 x 48 cm)
Collection Richard L. Feigen, New York

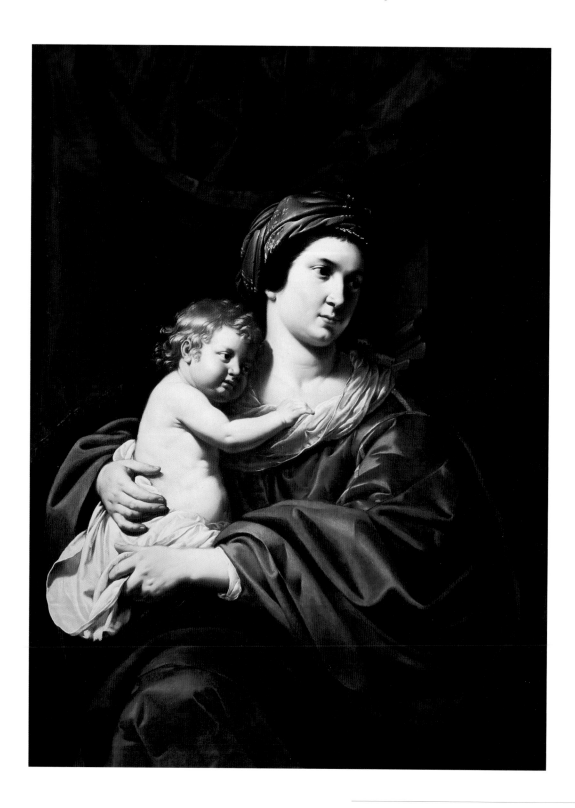

Jan van Bijlert (Utrecht 1597/98–1671 Utrecht)
Madonna and Child
Oil on panel
41 x 30 1/2 in. (105 x 78 cm)
Private Collection

Thomas de Keyser (Amsterdam 1596/97–1667 Amsterdam)
Saint John the Baptist in a Wooded Landscape
Oil on panel
24 1/2 x 18 1/2 in. (62 x 47 cm)
Private Collection

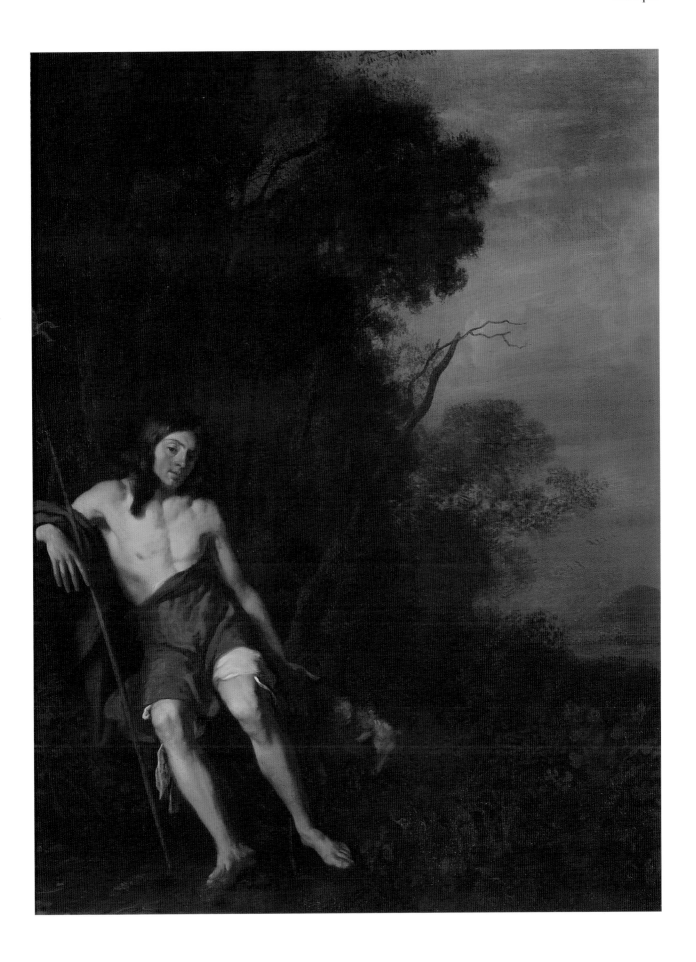

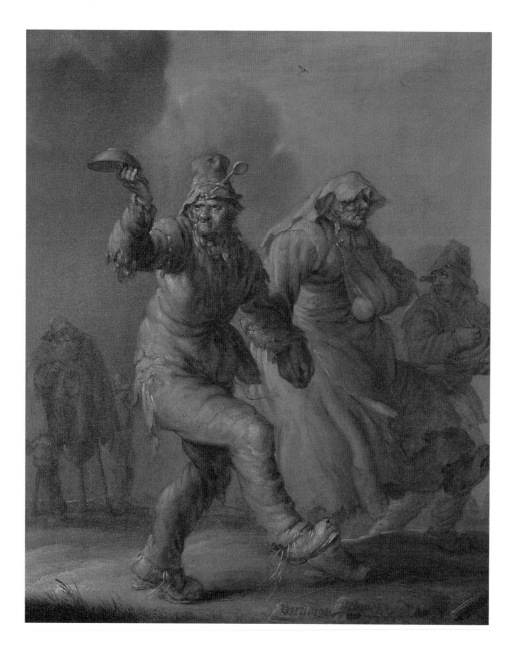

Adriaen van de Venne (Delft 1589–1662 The Hague)
Weeldigh Gebreck (Luxurious Injury), 1634
Signed and dated *1634*
Panel, grisaille
13 3/4 x 11 3/4 in. (35.5 x 30 cm)
Private Collection

Jan Steen (Leiden 1625/26–1679 Leiden)
Figures Carousing in an Inn
Oil on panel
21 3/4 x 17 3/4 in. (55.3 x 45.2 cm)
Private Collection

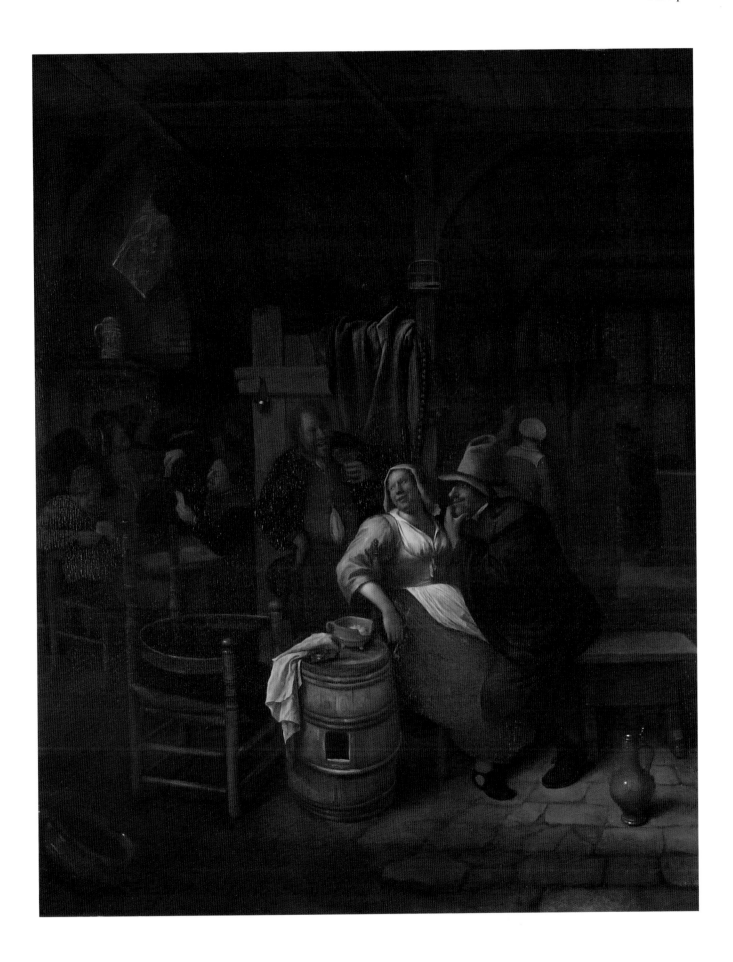

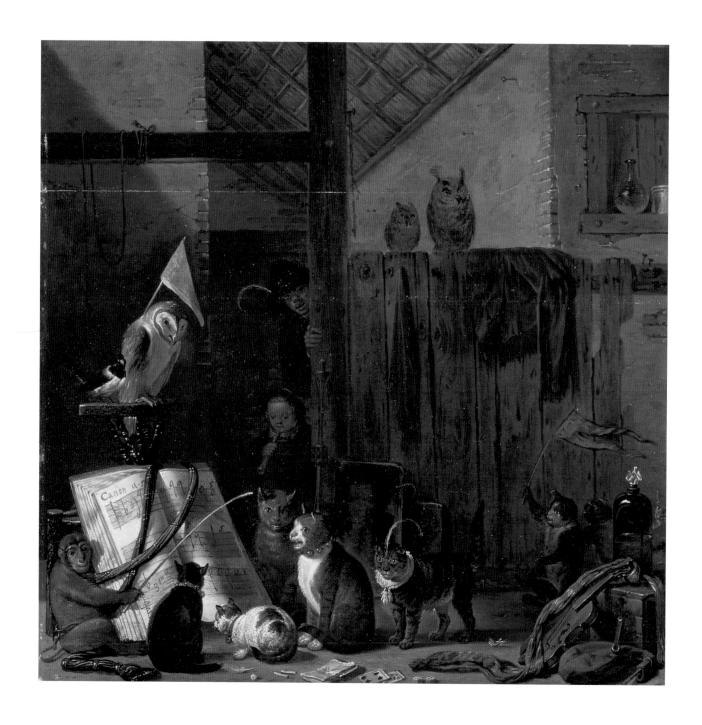

Cornelis Saftleven (Gorinchem c.1607–1681 Rotterdam)
A Concert of Cats, Owls, a Magpie and a Monkey in a Barn
Oil on panel
19 x 19 in. (48.2 x 48.2 cm)
Collection Suzanne and Norman Hascoe

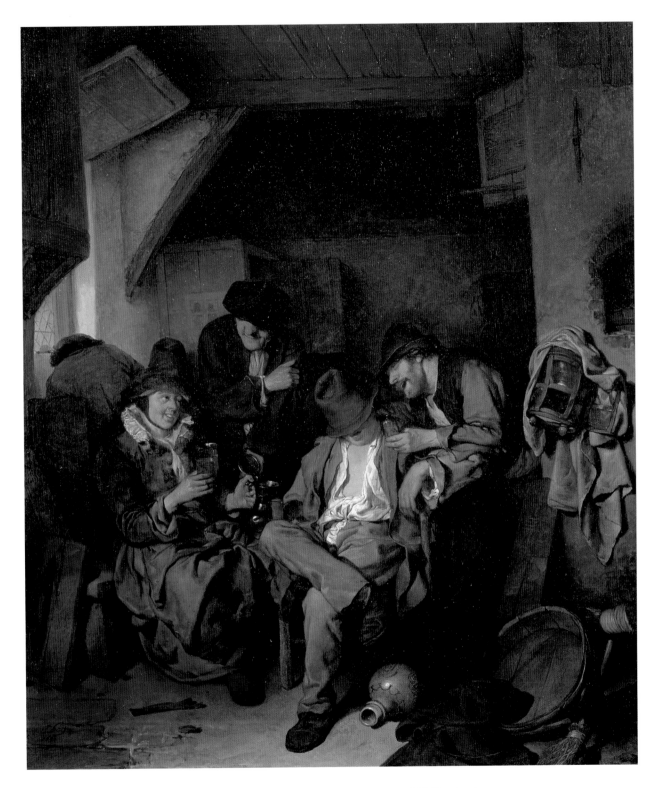

Cornelis Bega (Haarlem 1631/32–1664 Haarlem)
Merry Company in a Tavern, 1661
Signed and dated l.l. *cbega/1661*
Oil on panel
16 3/16 x 14 in. (41 x 35.5 cm)
Private Collection

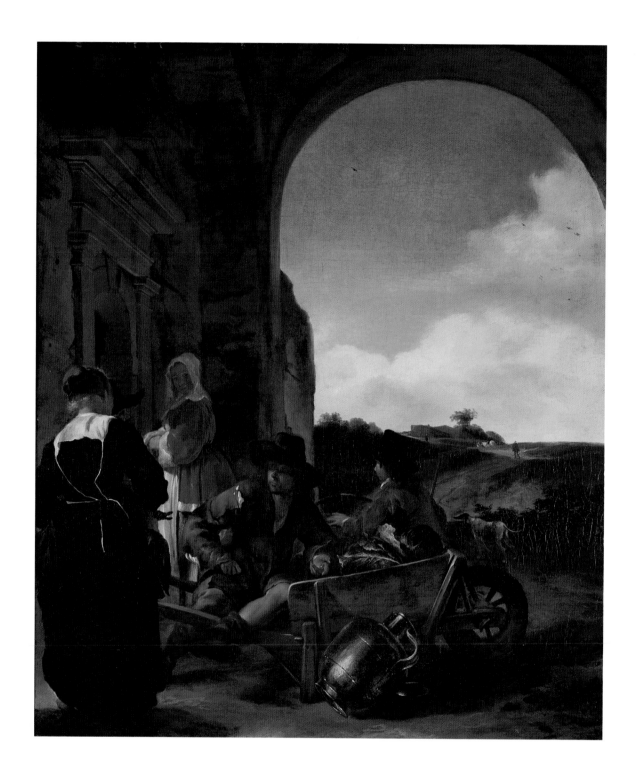

Jan Baptist Weenix (Amsterdam 1621–c.1660 Utrecht)
Customers with a Vegetable Merchant, 1656
Signed and dated l.l.: *Ao 1656 Gio. Batta. Weenix f.*
Oil on canvas
30 3/4 x 26 1/4 in. (79 x 68 cm)
Collection Suzanne and Norman Hascoe

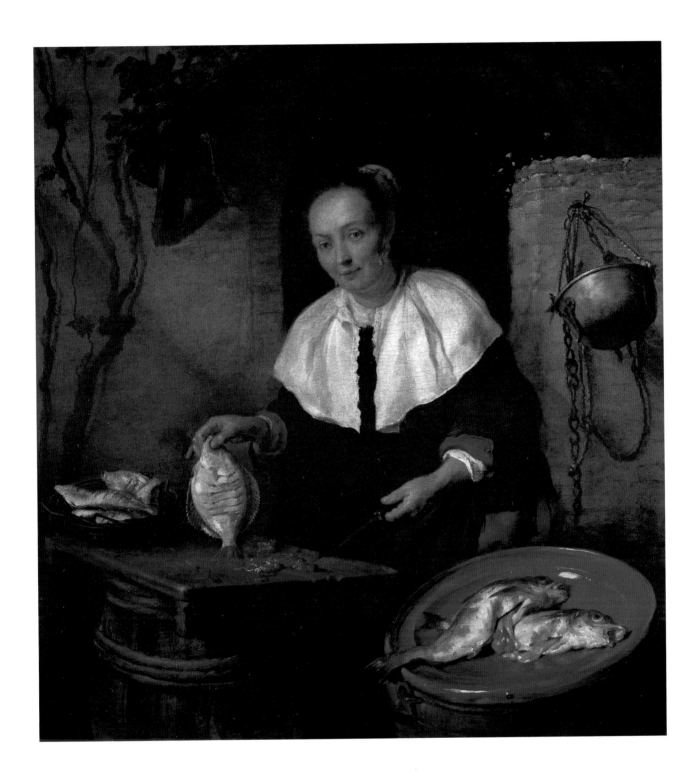

Gabriel Metsu (Leiden 1629–1667 Amsterdam)
Woman Selling Fish
Oil on canvas
12 x 10 3/4 in. (30.5 x 27.4 cm)
Private Collection

Jacob van Ruisdael (Haarlem c.1628/29–1682 Haarlem)
Dunes by the Sea, 1648
Signed l.r. *J. Ruisdael*
Oil on panel
18 x 24 in. (46 x 61 cm)
Collection Suzanne and Norman Hascoe

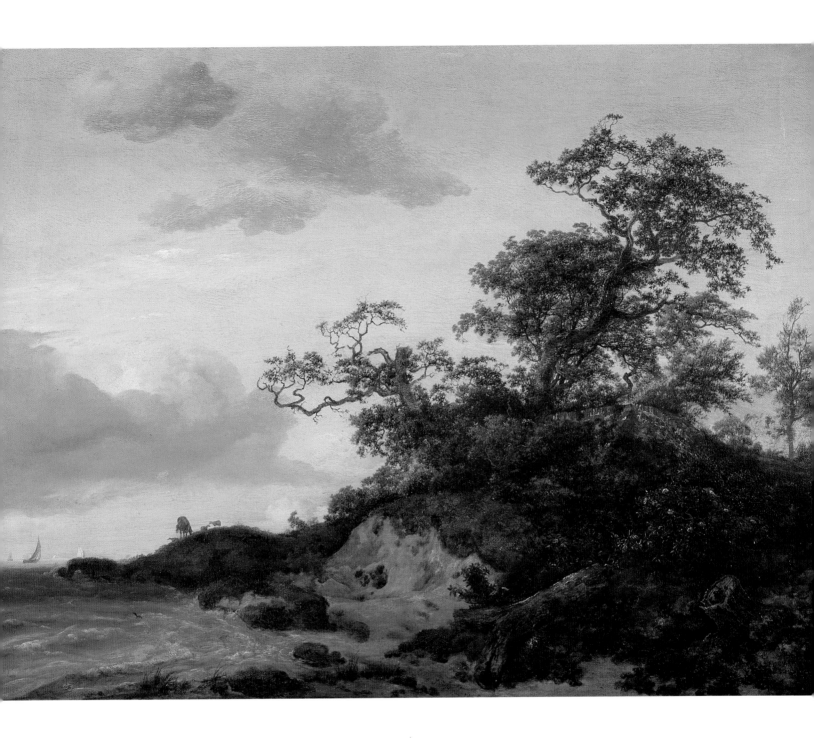

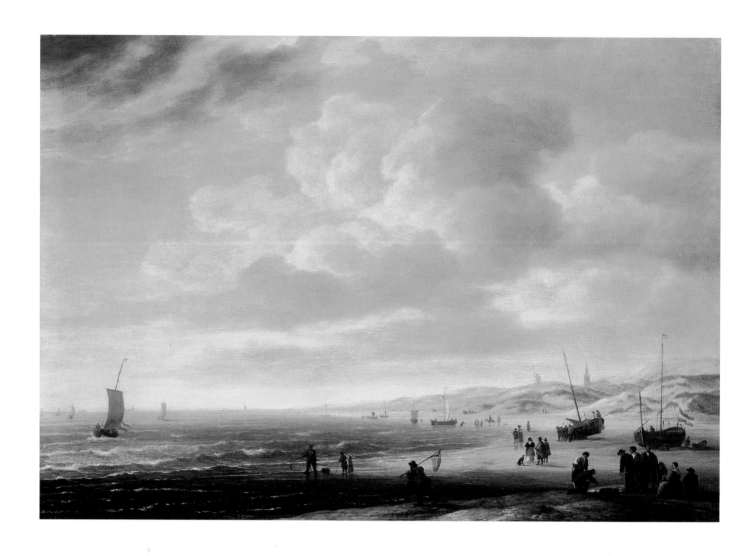

Simon de Vlieger (Rotterdam c.1601–1653 Weesp)
Beach Scene with Fishermen and Other Figures on the Shore, Shipping Beyond, c.1643–45
Oil on panel
18 1/4 x 26 in. (46.3 x 66 cm)
Private Collection

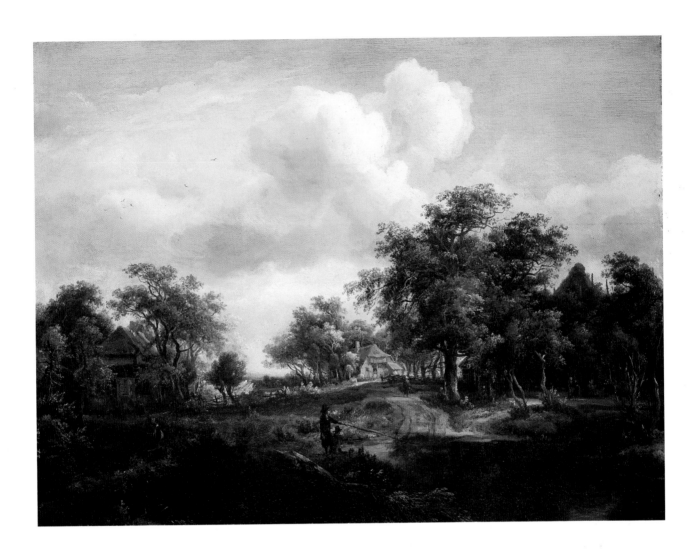

Meindert Hobbema (Amsterdam 1638–1709 Amsterdam)
Village Scene, 1661
Oil on panel
14 5/8 x 19 1/4 in. (37 x 48.5 cm)
Collection Mr. and Mrs. Richard M. Thune

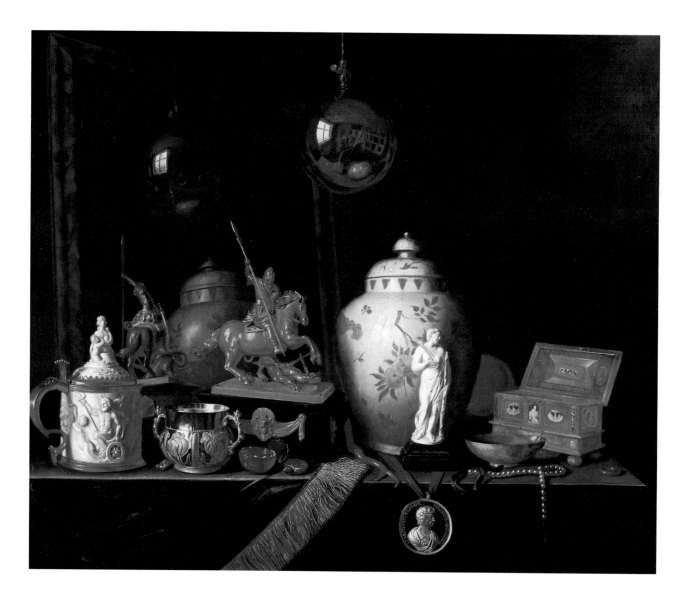

Pieter Gerritsz van Roestraten (Haarlem 1629/30–1700 London)
Trompe-l'oeil Still Life with Precious Objects
Signed l.r. *P. Roestratten*
Oil on canvas
37 1/2 x 43 1/4 in. (95.2 x 110 cm)
Private Collection

Rachel Ruysch (Amsterdam 1664–1750 Amsterdam)
Fruit and Flower Still Life on a Marble Ledge, 1683
Signed and dated *R.R. 1683*
Oil on canvas laid down on panel
21 1/4 x 16 3/4 in. (53.8 x 42.5 cm)
Collection Suzanne and Norman Hascoe

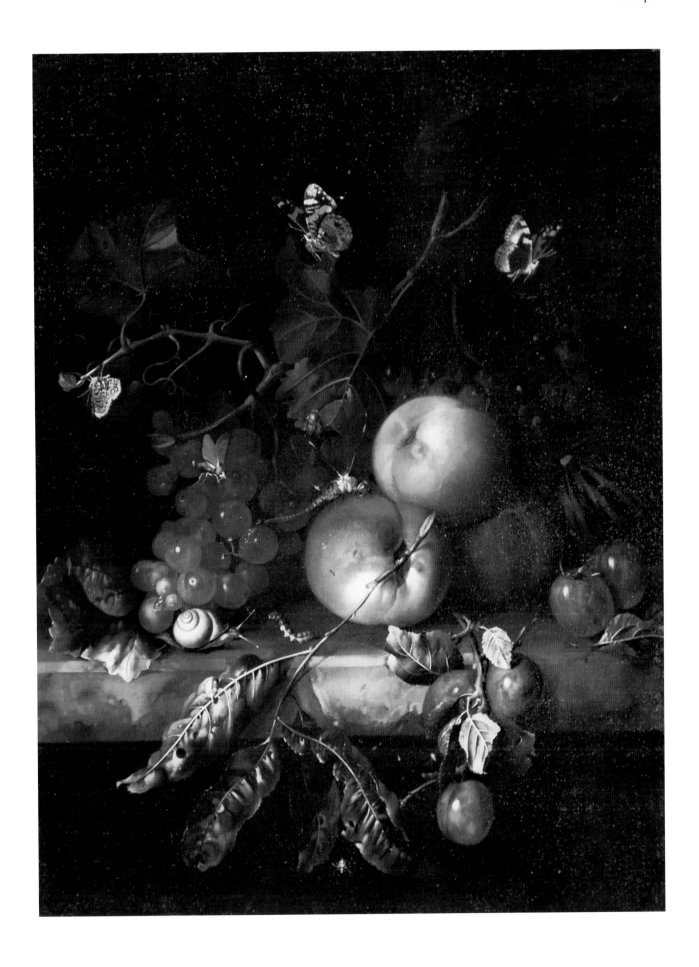

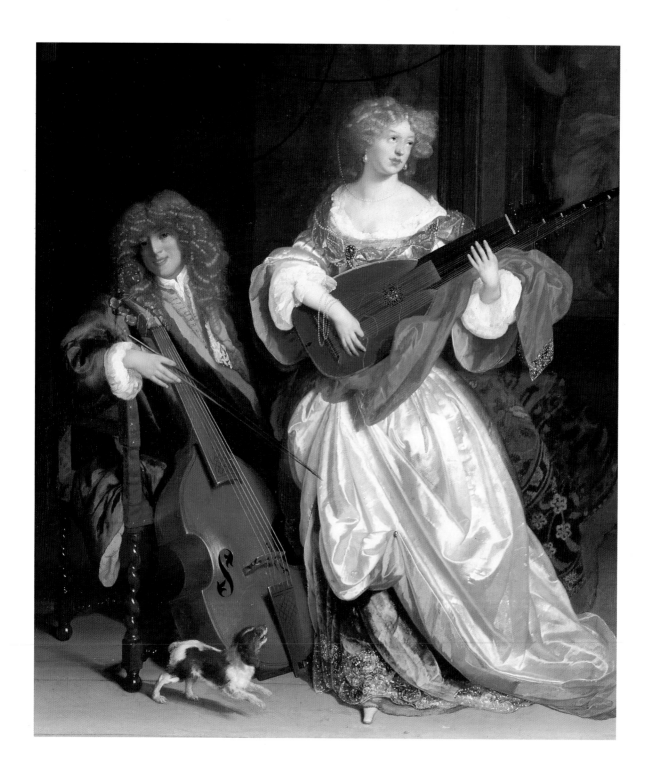

Adriaen van der Werff (Kralingen 1659–1722 Rotterdam)
An Elegant Couple Making Music in an Interior
Oil on canvas
19 x 14 in. (48 x 35.5 cm)
Private Collection

Frans van Mieris (Leiden 1635–1681 Leiden)
The Death of Lucretia, 1679
Signed l.r. *Mieris*
Oil on panel (arched top)
15 x 10 5/8 in. (38 x 17 cm)
Private Collection

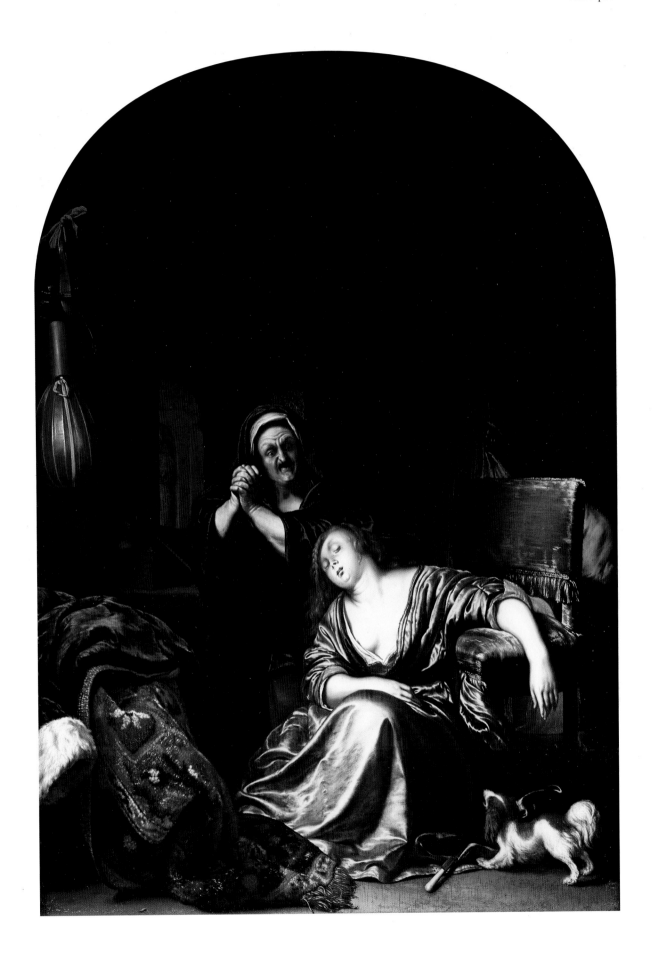

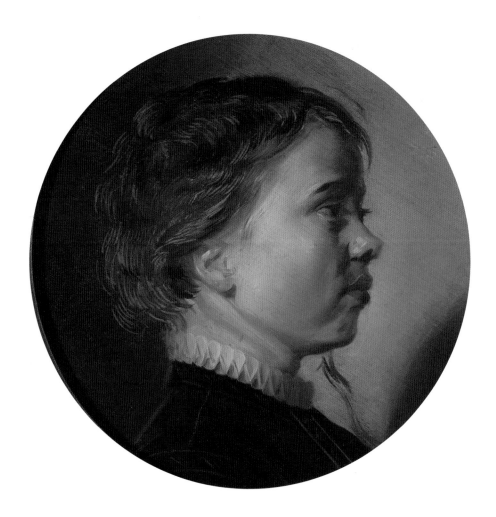

Judith Leyster (Haarlem 1609–1660 Heemstede)
Head of a Young Girl
Oil on panel
7 3/4 in. (20 cm) diameter
Collection Mrs. Thomas Mellon Evans

William Hogarth (London 1697–1764 London)
Miss Rich, also known as *A Charity Girl*, c.1730
Oil on canvas
16 1/2 x 13 3/4 in. (41.9 x 34.9 cm)
Collection Mr. and Mrs. Richard M. Thune

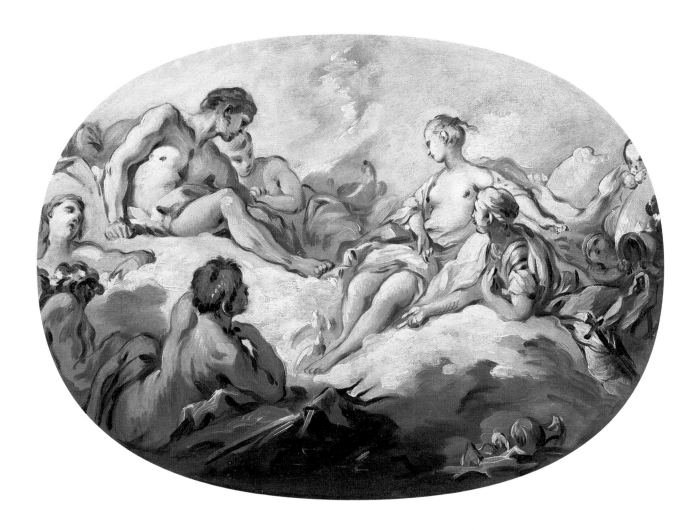

François Boucher (Paris 1703–1770 Paris)
The Apotheosis of Aeneas, 1746
Oil on paper laid down on canvas
Oval 9 3/4 x 13 1/2 in. (24.5 x 34 cm)
Private Collection, Courtesy Richard L. Feigen & Co.,
New York

Jean-Baptiste Pillement (Lyon 1728–1808 Lyon)
View of Tagus, Portugal, with Ships and Boats in a Rough Sea
and
A Mountainous Landscape with Two Footbridges and Travelers
(a pair), 1790
Both dated l.l. *1790*
Oil on canvas
24 x 33 3/4 in. (61 x 85.7 cm)
Collection Suzanne and Norman Hascoe

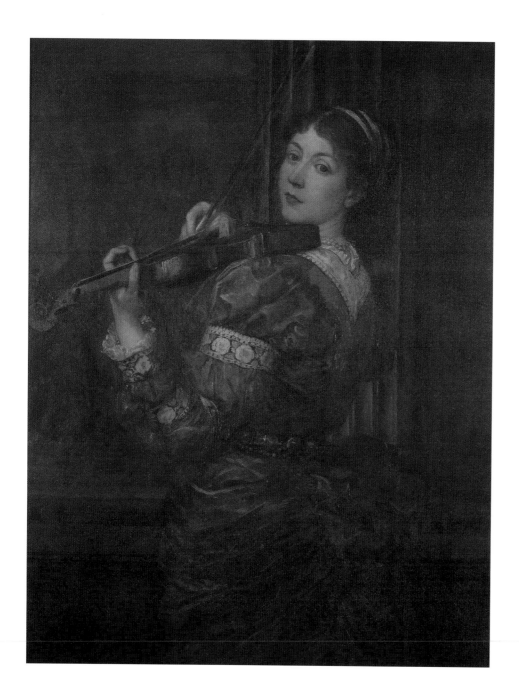

George Frederic Watts (London 1817–1904 London)
Portrait of Lady Lindsay Playing the Violin, 1876–77
Oil on canvas
43 1/2 x 33 1/2 in. (109.9 x 85.1 cm)
Private Collection

Adolphe William Bouguereau (La Rochelle 1825–1905
La Rochelle)
Girl with a Butterfly, 1893
Signed u.l. *W-BOVGVEREAV – 1893*
Oil on canvas
35 x 24 in. (88.9 x 61 cm)
Collection Mrs. John C. Newington

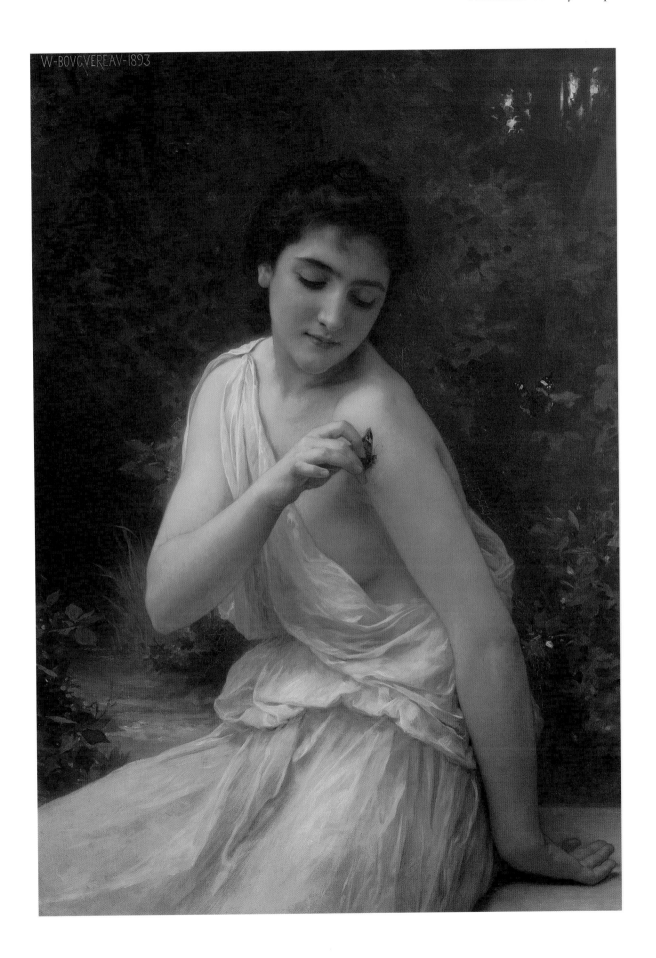

Giovanni Boldini (Ferrara 1842–1931 Paris)
Young Woman Reading in an Interior (Liseuse dans un salon), 1876
Signed l.l. *Boldini*
Oil on canvas,
28 1/2 x 22 1/2 in. (73 x 57 cm)
Private Collection

Italian Macchiaioli School, latter half of the 19th century
Woman Seated in an Interior
Oil on panel
15 3/4 x 11 1/2 in. (40 x 29.2 cm)
Private Collection

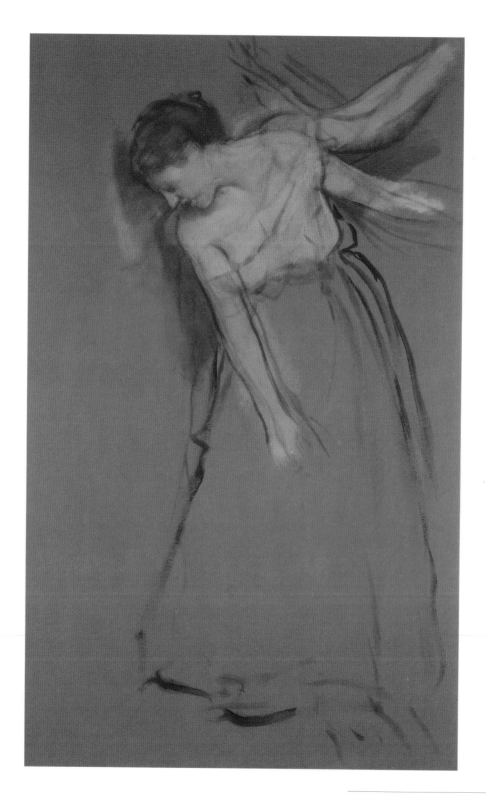

Edgar Degas (Paris 1834–1917 Paris)
Study of a Woman Standing, 1875
Gouache on brown paper with pastel
18 1/4 x 11 1/4 in. (47.4 x 30.3 cm)
The Walter and Molly Bareiss Family Collection of Art

Edgar Degas (Paris 1834–1917 Paris)
Petite Danseuse de Quatorze Ans (Little Fourteen-Year-Old Dancer)
Bronze, muslin and satin with a wood base
37 1/2 in. high (95 cm)
Private Collection

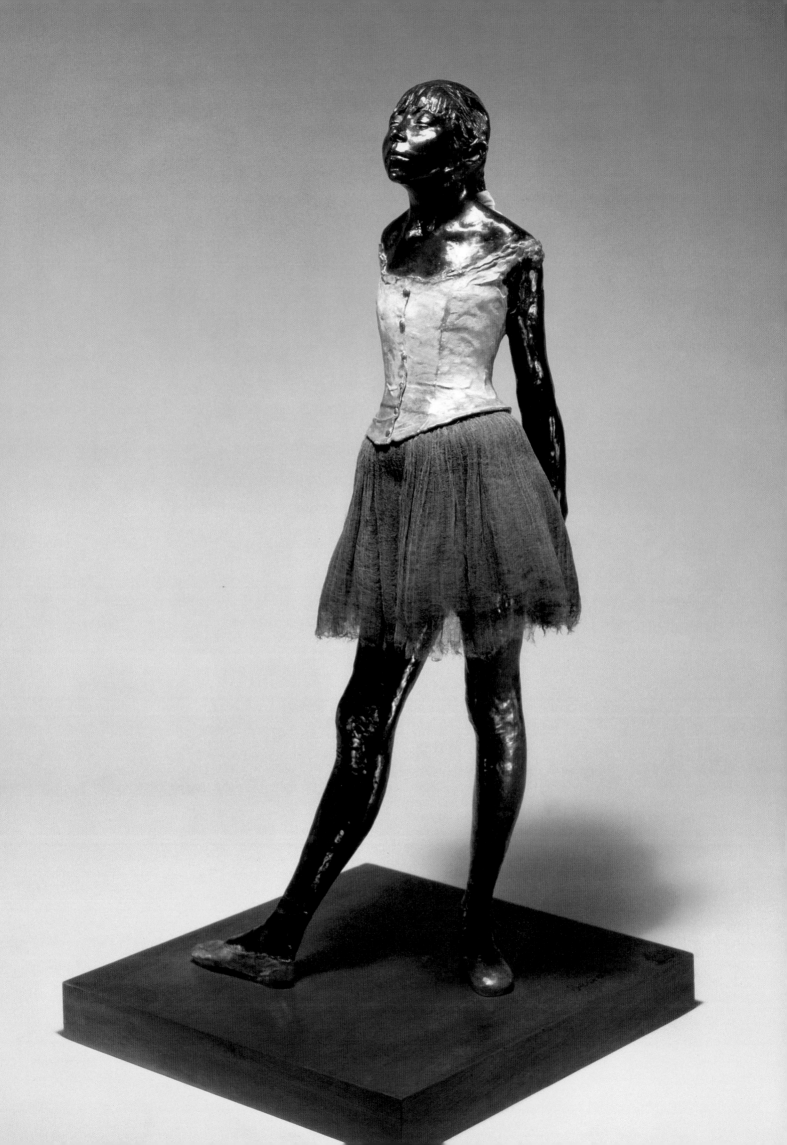

Edouard Manet (Paris 1832–1883 Paris)
Portrait de Manet par lui-même, en buste
(Self-Portrait, bust length), c.1878
Oil on canvas
33 5/8 x 28 in. (85.3 x 71 cm)
Private Collection

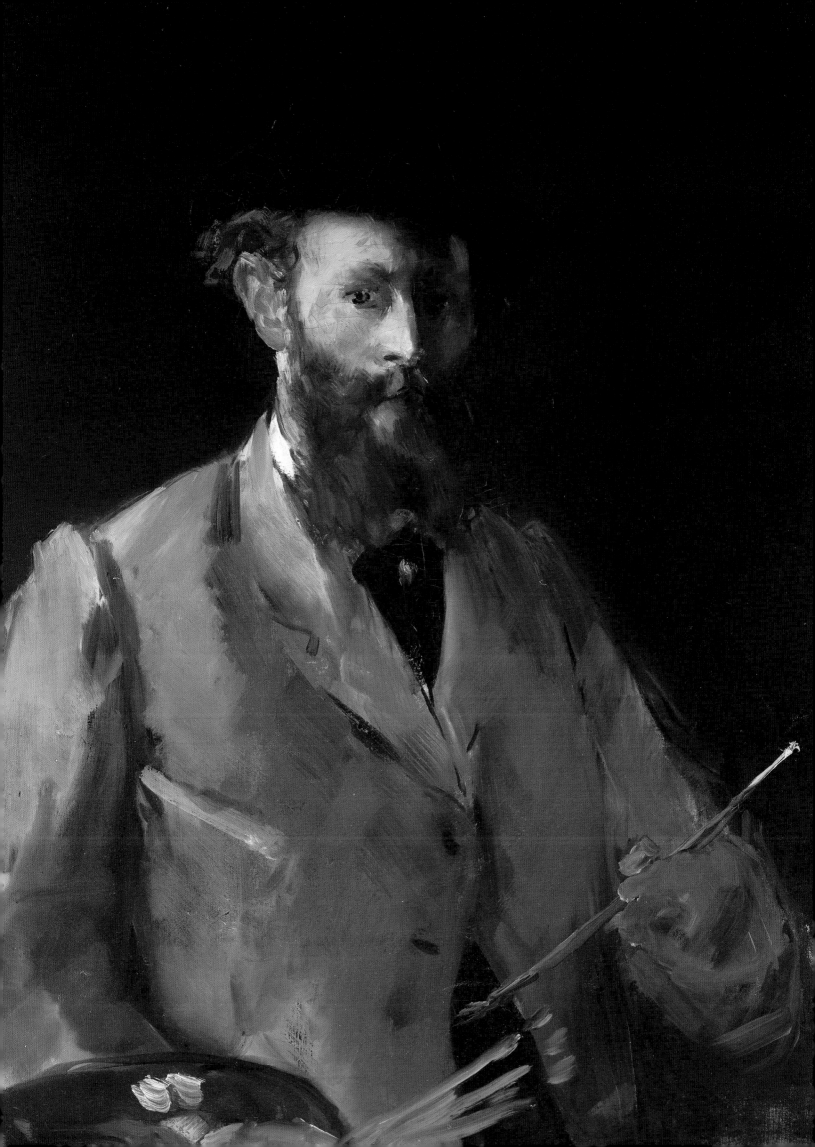

Camille Pissarro (St. Thomas 1830–1903 Paris)
Landscape in the Vicinity of Conflans Sainte-Honorine, 1874
Signed l.l. *C Pissarro*
Oil on canvas
17 3/4 x 22 in. (45 x 56 cm)
Private Collection

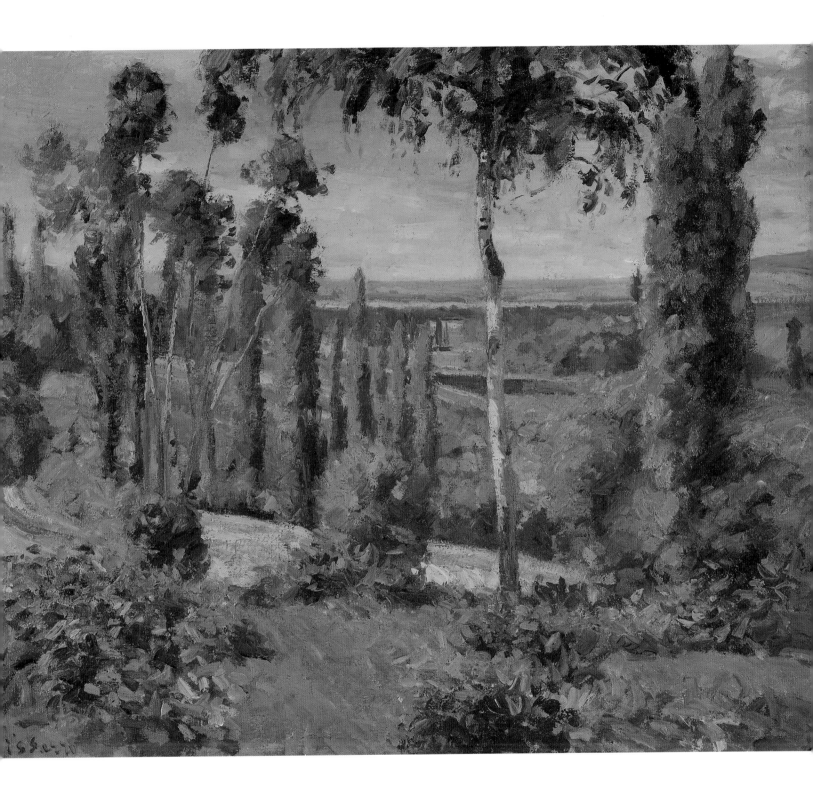

Claude Monet (Le Havre 1840–1926 Giverny)
The Cliffs near Fécamps, 1881
Signed and dated l.r. *Monet 81*
Oil on canvas
23 3/4 x 32 in. (60 x 81 cm)
Private Collection

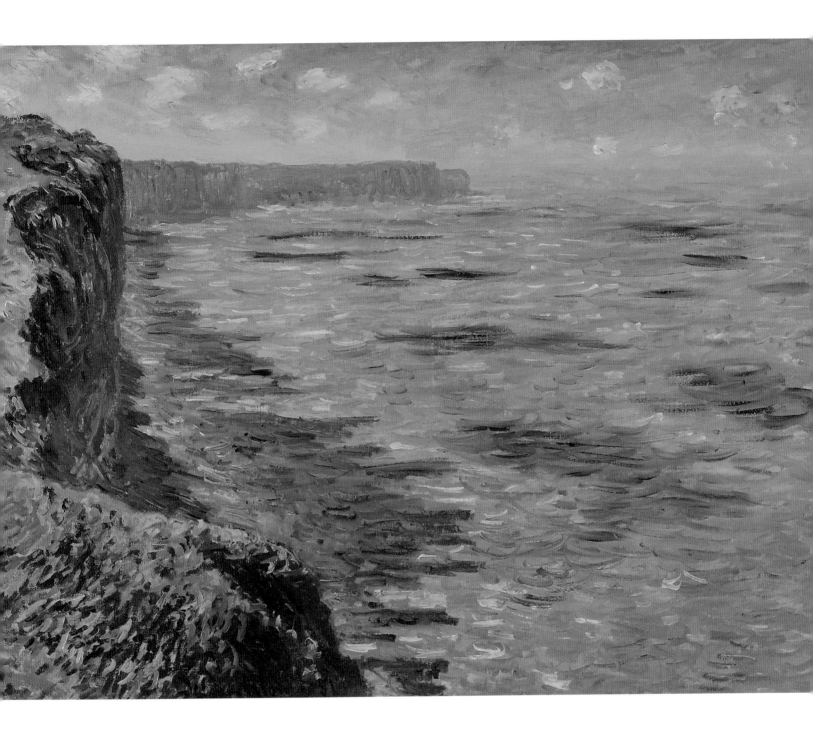

Vincent van Gogh (Zundert 1853–1890 Auvers-sur-Oise)
A Double Sided Sketchbook Page – A Still Life with Can,
Wineglass, Bread and Alum; Two Women and a Girl
Pencil and black chalk on paper
10 1/2 x 17 1/4 in. (26.7 x 43.7 cm)
Collection Toni and Ralph Wyman

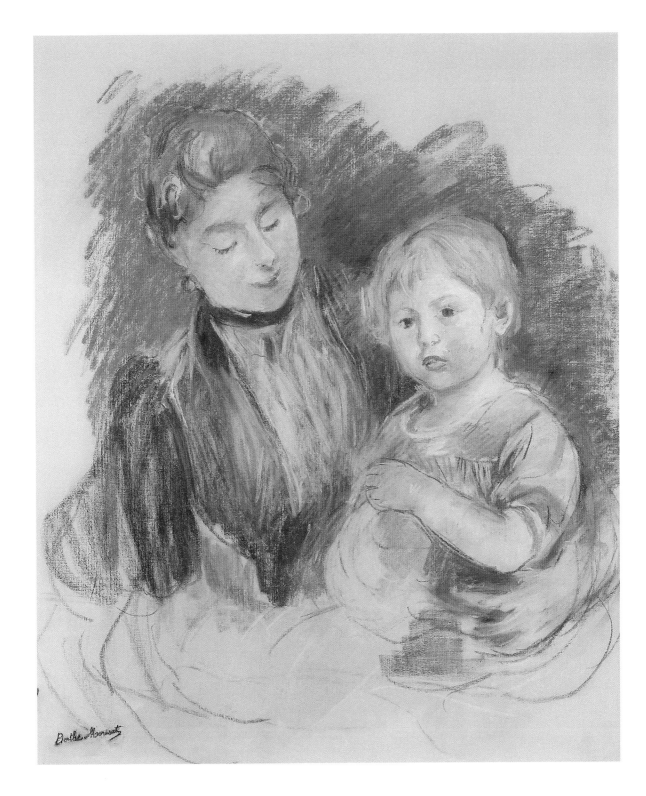

Berthe Morisot (Bourges 1841–1895 Paris)
Young Woman and Child, 1894
Signed l.l. *Berthe Morisot*
Pastel on paper
29 x 24 in. (73.7 x 61 cm)
Private Collection

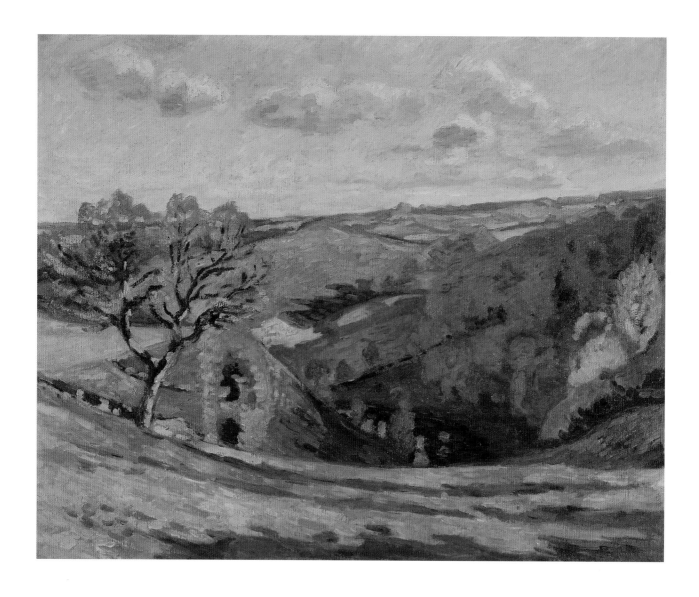

Armand Guillaumin (Paris 1841–1927 Crignon)
Landscape in Crozant in the Creuse Valley
Signed l.r. *Guillaumin*
Oil on canvas
23 5/8 x 28 3/4 in. (60 x 73 cm)
Private Collection

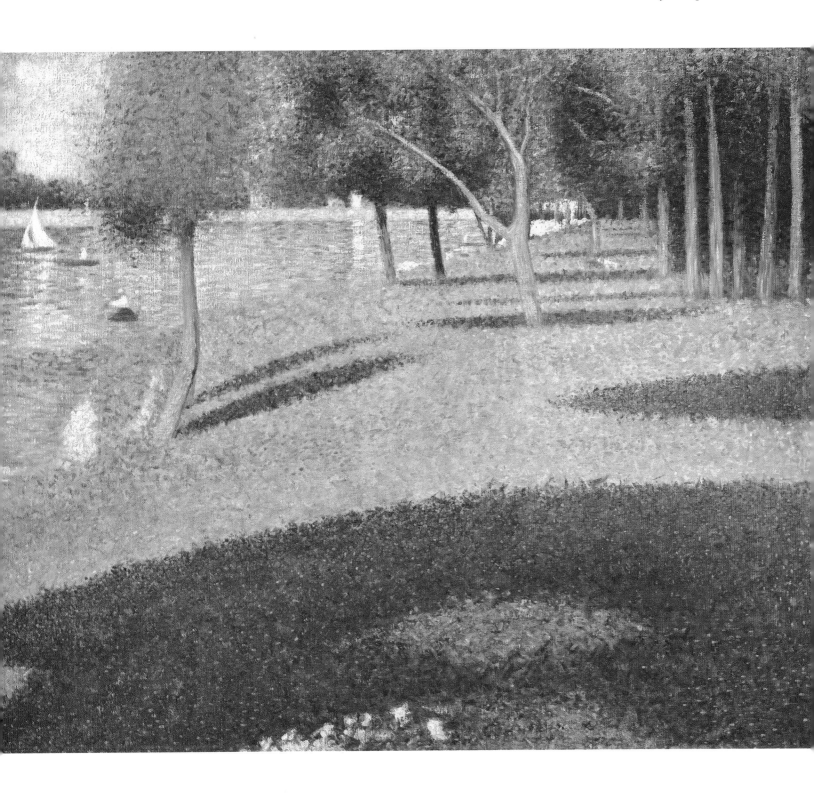

Georges Seurat (Paris 1859–1891 Paris)
Paysage, l'Ile de la Grande-Jatte (Landscape, Island of La Grande-Jatte), 1884
Oil on canvas
25 5/8 x 31 1/8 in. (65.1 x 79.1 cm)
Private Collection

51

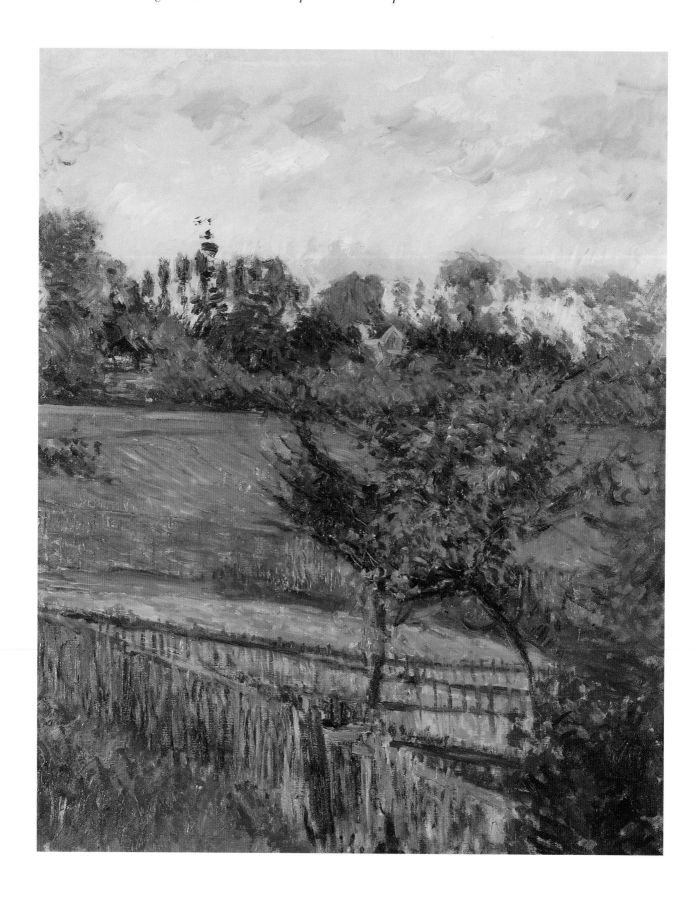

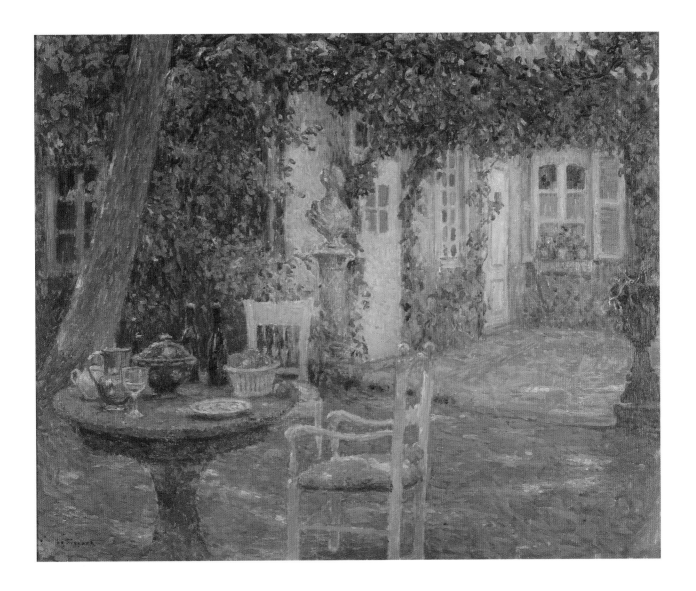

Henri Le Sidaner (Port Louis, Mauritius 1862–1939 Paris)
Landscape with a Table Set in the Garden of the Artist's
Home at Gerberoy, 1922
Signed l.l. *Le Sidaner*
Oil on canvas
23 5/8 x 28 3/4 in. (60 x 73 cm)
Private Collection

Gustave Caillebotte (Paris 1848–1894 Gennevilliers)
A Garden with Fruit Trees in a Landscape, 1882
Signed l.l. *Caillebotte*
Oil on linen
24 3/4 x 20 1/2 in. (62.9 x 52.1 cm)
Private Collection

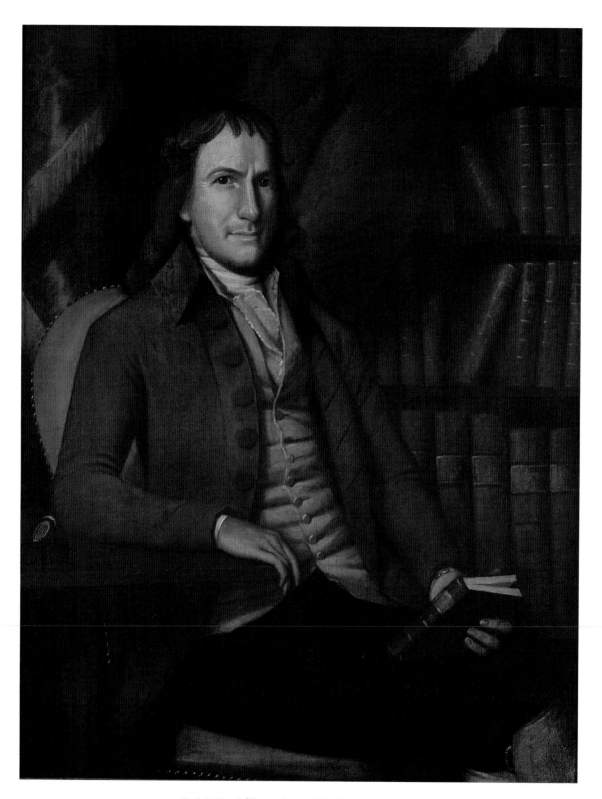

Ralph Earl (Shrewsbury, MA 1751–1801 Bolton, CT)
Portrait of Thomas Shaw, 1793
Oil on canvas
42 7/8 x 32 7/8 in. (107.2 x 82.2 cm)
Private Collection

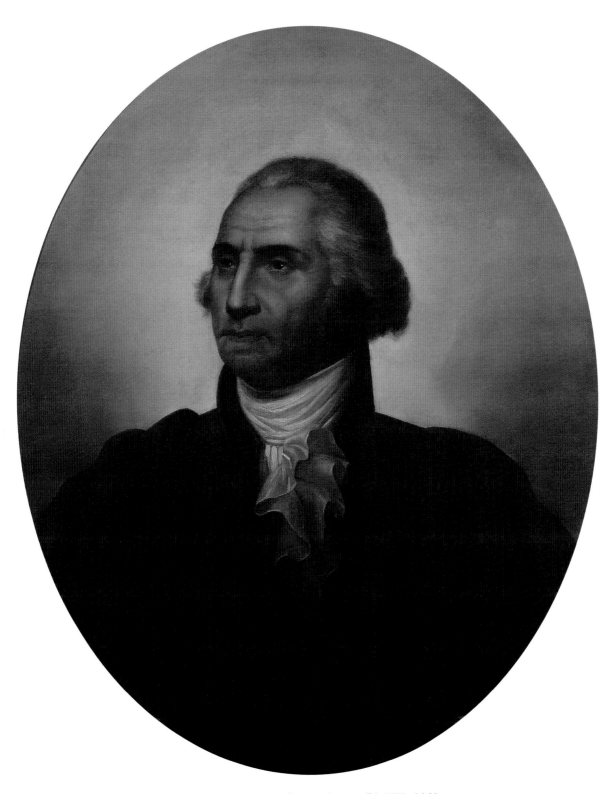

Rembrandt Peale (Bucks County, PA 1778–1860
Philadelphia, PA)
Portrait of George Washington, c.1840s
Oil on canvas
Oval, 38 1/2 x 30 1/2 in. (97.8 x 77.5 cm)
Collection Mr. and Mrs. Robert A. Simms

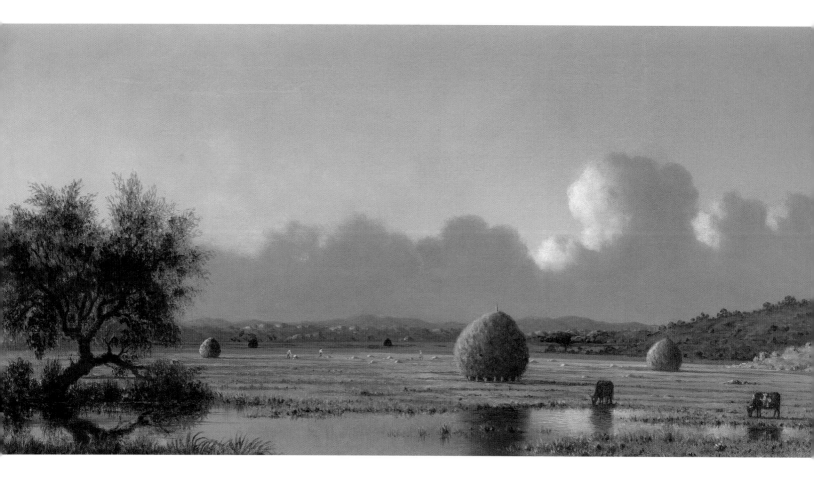

Martin Johnson Heade (Lumberville, PA 1819–1904
St. Augustine, FL)
Sunlight on Newbury Marshes, c.1865–1875
Signed l.l. *M. J. Heade*
Oil on canvas
13 x 26 in. (33 x 66 cm)
Private Collection

Jasper Francis Cropsey (Rossville, NY 1823–1900
Hastings-on-Hudson, NY)
Beach at Bonchurch, Isle of Wight, 1859
Signed and dated l.r. *J. F. Cropsey / Bonchurch / 1859*
Oil on canvas
11 1/2 x 19 1/2 in. (29.2 x 49.5 cm)
Collection Mrs. John C. Newington

Jasper Francis Cropsey (Rossville, NY 1823–1900
Hastings-on-Hudson, NY)
Anne Hathaway's Cottage, 1863
Signed and dated l.r. *F. Cropsey 63*
Oil on canvas
21 1/2 x 38 1/2 in. (54.6 x 97.8 cm)
Collection Mrs. John C. Newington

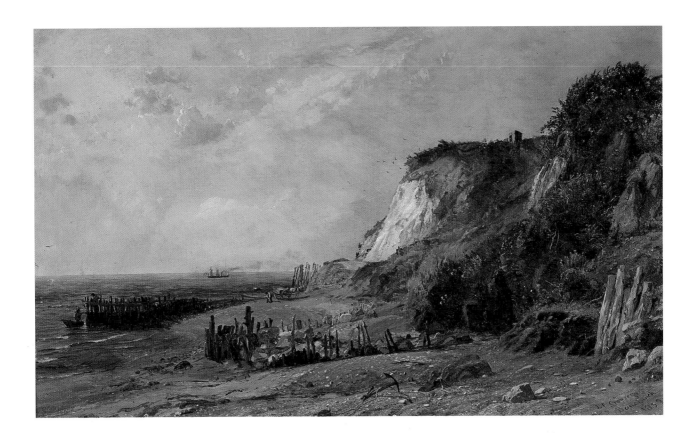

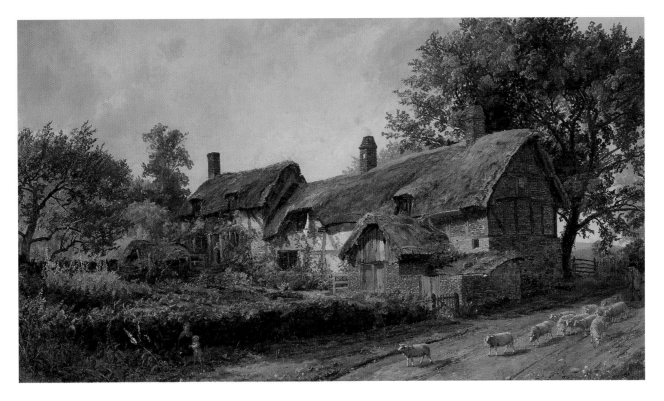

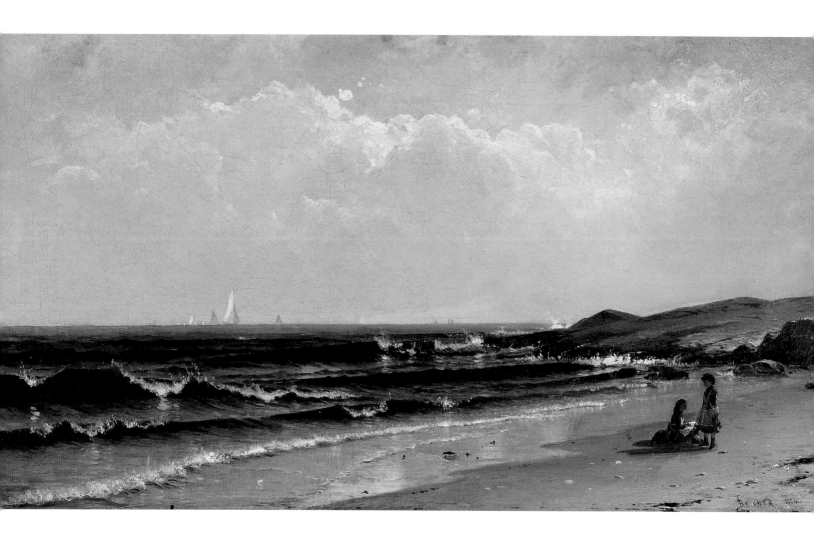

Alfred Thompson Bricher (Portsmouth, NH 1837–1908
New Dorp, NY)
Morning at Narragansett, 1874
Signed and dated l.r. *A. T. Bricher 1874*
Oil on canvas
17 x 31 3/4 in. (43.2 x 80.6 cm)
Private Collection

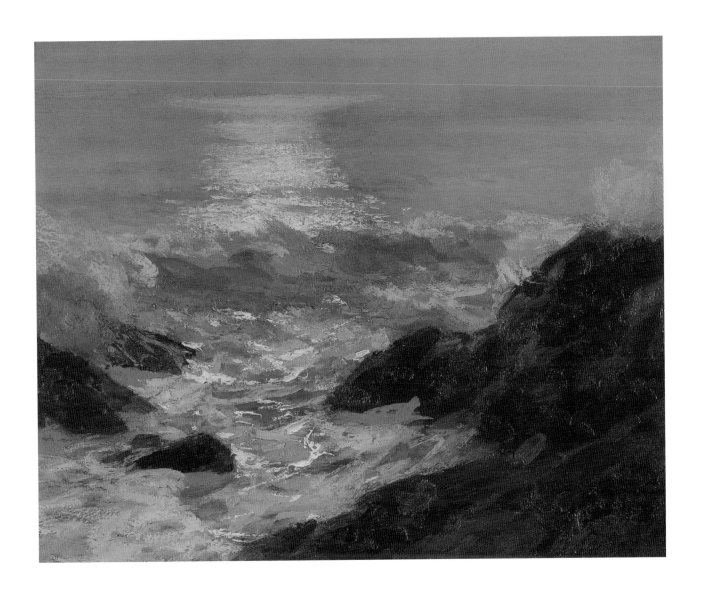

Edward Henry Potthast (Cincinnati, OH 1857–1927 New
York, NY)
Moonlight
Signed l.r. *E. Potthast*
Oil on composition board
16 x 20 in. (40.6 x 50.8 cm)
Collection Mrs. Hugh B. Vanderbilt

Willard Leroy Metcalf (Lowell, MA 1858–1925 New York, NY)
The Violets, 1903
Signed and dated u.l. *Willard L. Metcalf 1903*
Oil on canvas
30 x 26 in. (76.2 x 66 cm)
Collection Richard and Mary Radcliffe

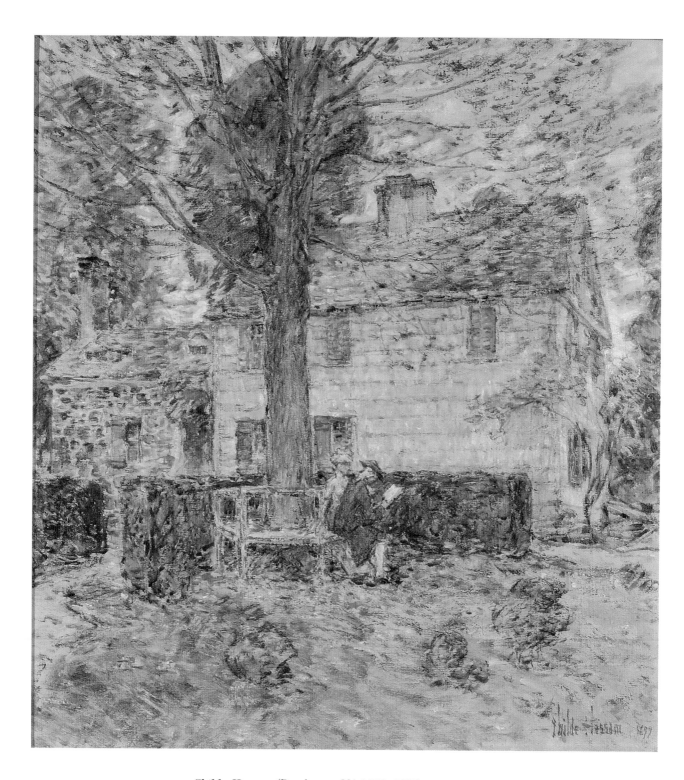

Childe Hassam (Dorchester, MA 1859–1935
Easthampton, NY)
Indian Summer in Colonial Days, 1899
Signed and dated l.r. *Childe Hassam 1899*
Oil on canvas mounted on board
22 x 20 in. (55.9 x 50.8 cm)
Collection Mr. and Mrs. Russell S. Reynolds, Jr.

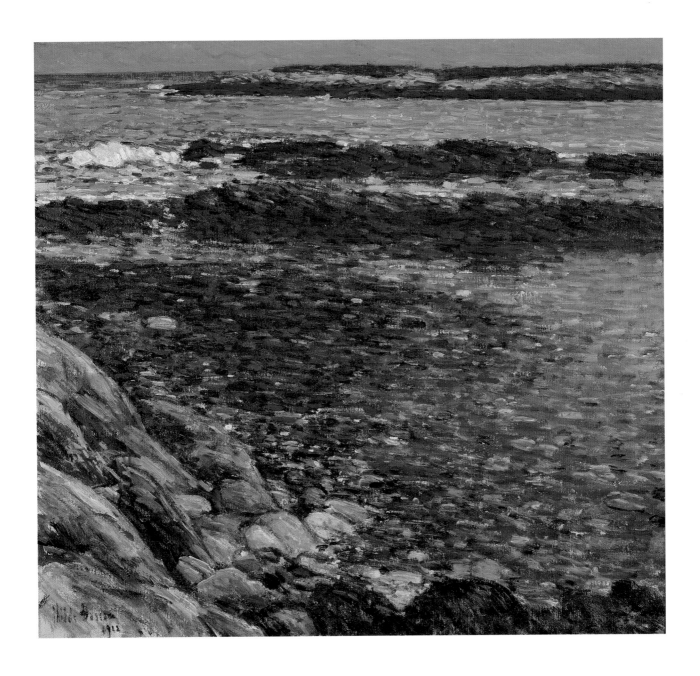

Childe Hassam (Dorchester, MA 1859–1935
Easthampton, NY)
Spanish Ledges, 1912
Signed and dated l.l. *Childe Hassam 1912*
Oil on canvas
22 1/4 x 24 in. (56.5 x 61 cm)
Collection Richard and Mary Radcliffe

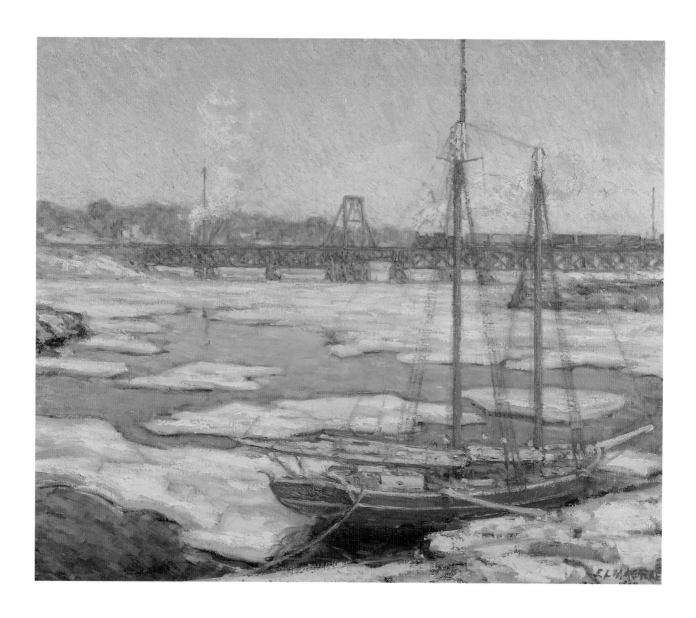

Elmer Livingston MacRae (New York, NY 1875–1953
Greenwich, CT)
Schooner in the Ice, 1900
Signed l.r. *EL MAC RAE /1900*
Oil on canvas
25 x 30 in. (63.5 x 76.2 cm)
Collection Mrs. Hugh B. Vanderbilt

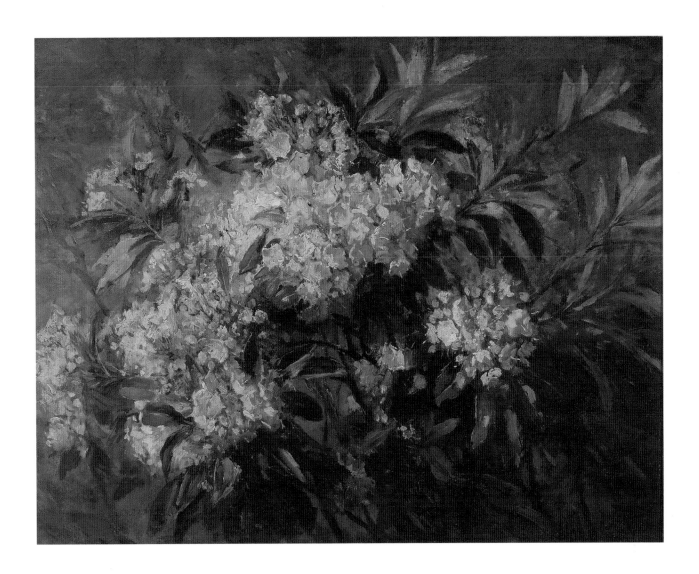

Matilda Browne (Newark, NJ 1869–1947 Greenwich, CT)
Laurel, c.1913
Signed l.r. *Matilda Browne*
Oil on canvas
23 1/2 x 30 in. (59.7 x 76.2 cm)
Collection Susan G. and James T. Larkin

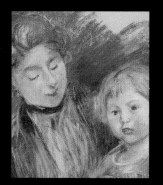

Catalogue of Exhibition

Attributed to Pieter Coecke van Aelst
(Aelst 1502–1550 Brussels)
Lovers Surprised by a Fool and Death,
c.1530
Oil on panel, 14 7/8 x 21 1/8 in. (37.8 x 53.7 cm)
Private Collection

Provenance: Jack Kilgore & Co., Inc.

A couple is seated on a wooded promontory above a village; a landscape with a distant view of a harbor is below on the right. They are dressed in extravagantly elegant and colorful attire and have been enjoying a picnic with wine and music (note the tazza at the left and the lute at the right). Suddenly from behind two tree trunks appears a fool in cap with bells, the symbol of Folly, and farther to the right, the personification of Time, a winged figure of a desiccated old man holding an hourglass and brandishing a spear.

The subject of a young couple threatened by death was descended from medieval art and constituted an emphatic admonition against youthful vanity, heedlessness and lust. Albrecht Dürer executed a drawing early in his career in this tradition depicting the "Pleasures of this World," with Death threatening elegantly dressed figures frolicking in a park (Ashmolean Museum, Oxford), as well as an engraving of 1498 on the theme of a *Young Couple Surprised by Death* (see respectively, E. Panosky, *Albrecht Dürer*, 1938, figs. 29 and 99). The subject of Death and fools surprising elegant or lascivious couples in their dalliance survived much later in Northern genre art (for discussion, see Amsterdam, Rijksprentenkabinet, exh. cat.; *Mirror of Everyday Life* [cat. by E. de Jongh and G. Luijten], 1977, nos. 27 & 28).

However, beginning with the art of the seventeenth century, it becomes progressively more difficult to gauge the degree to which these traditional, cautionary and allegorical themes, employing personifications of vices and mortality, retained censorious associations as genre scenes became more secularized, shedding their symbolic figures but retaining the gaiety and high life. Modern art historians have wrestled to excess with the question of to what extent a garden-variety, Dutch merry company scene is a sermon on self-indulgence and early death. It seems likely that the repetition of this popular theme ameliorated some of its hectoring message. But the present work is a very early and important example in this history, in which the warning is clear and undiluted.

The present work was regarded as the work of an anonymous artist of c.1530 active in Antwerp; however, it bears some resemblance in its nimbly animated figure types and colorful palette to works assigned to the artist, Pieter Coecke van Aelst (1502–1550), one of the leading painters of the art of the Lowlands during the Northern Renaissance. A painter, draftsman and book illustrator, as well as a designer of tapestries and stained glass, Coecke van Aelst remains a shadowy figure, notwithstanding efforts to reconstruct his oeuvre (see G. Marlier, *La Renaissance flamande: Pierre Coecke d'Alost*, 1966). Evidently influenced in his youth by his teacher, Bernard van Orley, and the Antwerp Mannerists, notably the Master of 1518, he became one of the first Northern artists to respond to the artists of the Italian Renaissance, Leonardo, Raphael and the latter's pupils.

Unfortunately, there is only one work confidently assigned to the artist on the basis of a document of 1585, namely the *Altarpiece of the Deposition* in the museum in Lisbon, while other works are attributed to him on the basis of engravings after these works.

Cornelis Bega (Haarlem 1631/32–1664 Haarlem)
Merry Company in a Tavern, 1661
Signed and dated l.l. *cbega/1661*
Oil on panel, 16 3/16 x 14 in. (41 x 35.5 cm)
Private Collection

Provenance: Sale London (Christie's), July 10, 1914, no. 97; Sale Amsterdam (F. Muller), May 25, 1919, no. 102; Sale Lek (Mensing), March 31, 1925, no. 2; Sale Amsterdam (F. Muller), March or April 1926; Private Collection, Europe; Sale London (Christie's), December 10, 1982, no. 13; with Colnaghi's, London and New York; Private Collection, U.S.; with Jack Kilgore, New York; acquired from Otto Naumann, New York.

Literature: M.A. Scott, "Cornelis Bega (1631/32–1664) as Painter and Draughtsman," dissertation, University of Maryland, College Park, 1984, cat. no. 84, pp. 306–307, fig. 108, p. 534.

A specialist in peasant subjects, Cornelis Bega was celebrated by the chronicler of artists' lives, Arnold Houbraken, in his *De Groote Schouburgh*, as the first and best pupil of the famous low-life painter Adriaen van Ostade. Bega came from an artistic family. His father was a gold- and silversmith and his mother was the daughter of the renowned painter Cornelis van Haarlem, one of the leading Mannerist artists in Haarlem. While little is known of Bega's life and training, he may have made a trip to Italy, since a drawing in the Weimar museum tentatively attributed to him is inscribed "Bega Romae." In 1653 he traveled to Germany, Switzerland and France in the company of three other artists – Vincent van er Vinne, Theodor Helmbreker and Willem de Bois. He returned to Haarlem the same year and was inscribed in the Guild of St. Luke in 1654.

Bega eschewed the history painting subjects that his grandfather favored for images of peasants carousing in taverns, singing, drinking and occasionally dancing, although he at times painted the burgher classes. Bega also painted several images of alchemists, by then an established low-life theme. The comical low-life tradition had been well formed in Haarlem by artists like Frans Hals, Jan Miense Molenaer, Adriaen and Isaac van Ostade. While Adriaen van Ostade's peasants (particularly around 1650 when Bega would presumably have been apprenticed to him) are squat but nimble and freely painted little figures, Bega's become progressively more naturalistic and individualized and are executed with a darker, blacker palette and a smoother, descriptive touch that seems to reflect his exposure to the Leiden *fijnschilders'* tradition of Gerard Dou and Frans van Mieris. Yet figures like the slumped and unbuttoned drinker with slouch hat in the foreground of the present scene, who slumbers despite the caterwauling all about him, and some of the coarser, neckless and potato-nosed types at the back clearly descend from Ostade. The pretty, smiling drinker with tipsy

headgear at the left and the bearded fellow who hollers into the sleeper's ear are images that recur elsewhere in Bega's works. The former appears in many of his musical (e.g.; Stockholm museum, no. 310, dated 1663) and maternal subjects, while the latter figures are found in a drawing in the museum in Brussels and in a tavern scene painting in the Indiana University Museum, Bloomington. We note with admiration the fine attention paid to the modest still life details on the right – a misshapen lantern hung with a rag on the wall, and whisk brooms and a wooden tub jumbled on the floor beside an overturned jug.

Bega was only thirty-two or -three when he died, probably of the plague. It is especially regrettable that he was taken early because the dates on his paintings indicate that his best period was his last. His technique was most refined and drawing most innovative and assured in 1661-1664, the last three years of his life. Another merry company in a tavern, also dated 1661, is in the Musée des Beaux Arts in Brussels, inv. 3369.

Jan van Bijlert (Utrecht 1597/98–1671 Utrecht)
Madonna and Child
Oil on panel, 41 x 30 1/2 in. (105 x 78 cm)
Private Collection

Provenance: Collection of Baroness Sigrid Ralamb, Stockholm, 1912; Collection of Barbo Stigsdottir, 1924; Sale Stockholm (Bukowski), 15 November 1975, no. 994, as «French School, 17th Century»; Leger Gallery, London 1976; Slaes New York (Sotheby's), 4 July 1980, no. 142; Collection of Mr. & Mrs. Morton B. Harris, New York.

Exhibited: New York, National Academy of Design, *Dutch and Flemish Paintings from New York Private Collections*, cat. by Ann Jensen Adams, 1988, no. 4.

Literature: Paul Huys Janssen, *Jan van Bijlert 1597/98–1671. Catalogue Raisonné* (Amsterdam, 1998), pp. 58, 97–98, cat. 12, pl. 16, color pl. III.

Son of a glass engraver and the pupil of Abraham Bloemart, Jan van Bijlert was one of the Dutch painters known as the Utrecht Caravaggisti. Like Gerard van Honthorst and Hendrick ter Brugghen, he was born in Utrecht and traveled to Italy, where he was influenced by the revolutionary Baroque master, Caravaggio. The Utrecht Caravaggisti absorbed the Italian painter's realism, half-length, life-size compositions and taste for genre subjects, but combined these with a clearer, more silvery light and brighter palette. Although the present work is not dated, Paul Huys Janssen has characterized it as one of the painter's masterpieces and the earliest of a series of half-length images of the Virgin and Child and related allegories of *Caritas* (another subject featuring a mother with infants) which van Bijlert began in the 1630s. These became progressively cooler and more classicizing (see the other examples in the museums in Quimper and Braunschweig, with the dealer Lawrence Steigrad and in a German Private Collection; Janssen cats. 61, 15, 13 and 14). When the painting was exhibited in New York in 1988, Ann Adams observed that the Madonna's graceful pose in holding the

Christ Child to her side recalls her counterpart in Caravaggio's famous *Madonna of the Rosary* (Kunsthis-torisches Museum, Vienna), which surprisingly was already in Amsterdam by 1617, in the collection of the artist Louis Finson, into whose family van Bijlert's daughter later married. However, Janssen has correctly observed that the theme and composition of the present work are more typical of French Caravaggists, specifically Simon Vouet, than of the Dutch. Van Bijlert traveled to Italy via France and may have made a second trip to Paris in the 1630s when he could have been influenced by a series of half-length images of the Madonna and Child in which Vouet specialized. In this connection, it may be significant that van Bijlert's pupil, Abraham Willaerts, went on to study under Vouet.

Giovanni Boldini (Ferrara 1842–1931 Paris)
Young Woman Reading in an Interior (Liseuse dans un salon), 1876
Signed l.l. *Boldini*
Oil on canvas, 28 1/2 x 22 1/2 in. (73 x 57 cm)
Private Collection

Provenance: Sale Paris (Millon & Robert), December 2, 1998, lot 23, ill.; Sale New York (Sotheby's), May 1, 2001, lot 160, ill.

Son of a painter who made part of his living copying Old Master paintings, Giovanni Boldini became one of the most fashionable artists of his day, specializing in portraits of well-to-do and famous sitters as well as genre scenes of high life. Early in his career he was influenced by the Italian nineteenth-century painters known as the *Macchiaioli*, especially Telemaco Signorini. He studied briefly in 1862 at the Academy in Florence but had little patience for formal training. By nature elegant and modish, he was a dandy whose pictures celebrate the leisure and entertainments of high society.

The present work is an excellent example of the type of luxurious genre painting of highborn women in drawing rooms that made Boldini a success in Paris after he settled there in 1871. Descended from seventeenth-century interior genre scenes by Gerard ter Borch and views of aristocratic dalliance by Antoine Watteau, these works demonstrate the concern with chic manners and fashion Boldini shared with his contemporaries, Auguste Toulmouche, Charles Gleyre, James Jacques Joseph Tissot and Alfred Stevens. However, Boldini's works have a more brilliant palette and more painterly virtuoso touch than those of his colleagues. Every detail in this painting speaks to languorous elegance and insouciance: the woman's pose, her clinging pink silk gown, flared lace collar, the throw spiraling from her lap and the rich neoclassical interior setting. She is seated on an Empire painted parcel-gilt *fauteuil à la Reine*, and at the back of the room is an Empire ormolu-mounted mahogany *secrétaire abbatant* as well as a mahogany *directoire*. The brilliant rug with bold geometric patterns and the neoclassical tapestry complete the scene. Boldini had explored the subject of a woman reclining in a chair for several years; compare as examples, the *Woman in a Rocking Chair* (dated 1874, private collection; repr. T. Panconi, *Giovanni Boldini* [1998], p. 119) and *Woman Seated Reading a Book*, which employs virtually the same pose (dated 1875, private collection,

Turin; exh. cat., *Boldini*, Milan, Palazzo della Permanente, 1989, no. 26, ill.).

Boldini also made a reputation in London, painting swagger portraits of, among others, the painter James A. McNeill Whistler and the Duchess of Marlborough. In his maturity his popularity throughout Europe was comparable to that of John Singer Sargent, another master of the society portrait. In 1901, he was the celebration of both the Venice Biennale and the Paris Salon. With the rise of modern art, Boldini fell out of favor but he returned to fashion in the later twentieth century and is now one of the most sought-after painters of the Belle Époque.

François Boucher (Paris 1703–1770 Paris)
The Apotheosis of Aeneas, 1746
Oil on paper laid down on canvas,
Oval, 9 3/4 x 13 1/2 in. (24.5 x 34 cm)
Private Collection, Courtesy Richard L. Feigen & Co., New York

Provenance: Alphonse Trézel; his sale Paris (Galerie Charpentier) May 17, 1935, no. 43; Private Collection, New York.

Literature: (possibly) P. de Nolhac, *François Boucher, 1703–1770* (Paris 1907), p. 118; A. Ananoff and D. Wildenstein, *François Boucher*, (Lausanne and Paris, 1976), vol. 1, p. 414, no. 305, fig. 881; J. Fack, "The Apotheosis of Aeneas: A Royal Boucher Rediscovered," *The Burlington Magazine*, vol. 119, no. 897 (December 1977), p. 830, n. 13; A. Ananoff, *L'Opera completa di Boucher* (Milan, 1980), p. 111, no. 316, ill.

One of the greatest decorative history painters of his age, François Boucher studied initially with his father, then with François Lemoine, before working as an engraver, producing among other works prints after Watteau. In 1724 he won the Grand Prix and traveled to Italy in 1727 in the company of Carle van Loo. Upon his return in 1731, he established himself as a history painter and in 1735 received royal commissions for decorations for Versailles. From then on he took part in the most important decorations and remodelings of the royal residences at Versailles and Fontainebleau, the *Bibliothèque du Roi*, Marly and Choisy. He also worked on decorations for various hôtels and executed set designs for the opera as well as tapestry designs. A highly productive artist, Boucher also produced portraits, landscapes, religious paintings, genre and pastoral scenes, and *chinoiseries*. After Carle van Loo's death, Boucher was appointed *Premier Peintre du Roi*. He supervised a large studio and had many imitators.

The present painting is a preliminary oil sketch for *The Apotheosis of Aeneas*, which, together with its pendant, *The Forge of Vulcan* (both preserved in the Louvre, Paris) was commissioned in 1746 to decorate the Dauphin's apartments at Versailles and later hung in the royal chambers at Marly. Boucher often worked out his early ideas for compositions with oil sketches. A second, more freely executed *esquisse* for the painting is also known (private collection, Paris; see *Eloge de l'Ovale*, exh. cat. Paris, Galerie Cailleux, 1975, no. 4, ill.). There are relatively few changes between the present work and the final design, but several of the figure's gestures

have been altered, a putto has been added, and the format converted to a rectangle. Boucher treated the subjects of the Apotheosis of Aeneas and the Forge of Vulcan more than once. The Trojan prince Aeneas, who survived so many adventures through Jupiter's protection in Virgil's epic poem, the *Aeneid*, was regarded as an ancestor of the founders of Rome, thus proof of the divine authority of the French empire and a fitting subject for royal decorations.

Adolphe William Bouguereau (La Rochelle 1825–1905 La Rochelle)
Girl with a Butterfly, 1893
Signed and dated u.l. *W-BOVGVEREAV - 1893*
Oil on canvas, 35 x 24 in. (88.9 x 61 cm)
Collection Mrs. John C. Newington

Bouguereau is both admired and reviled as one of the greatest nineteenth-century academic painters. Born to a modest family in La Rochelle, he began painting portraits in the 1840s and moved to Paris in 1846, where he entered the École des Beaux-Arts. Like Alexandre Cabanel, Jean-Jacques Henner and Gustave Moreau, he studied with François-Edouard Picot, who had been a pupil of the great Neo-Classicist, Jacques Louis David. Characteristically, Bouguereau seems to have ignored the political upheavals of 1848. In 1850 he won the *Prix de Rome* and spent four years in Italy studying the works of Raphael and other High Renaissance artists, as well as earlier masters like Signorelli and Giotto. He married a young American artist, Elizabeth Jane Gardner.

Bouguereau went on to become one of the most highly celebrated academic artists of his day, exhibiting at the official Salon, teaching at the Académie Julian, and painting hieratic religious scenes, classical and mythological subjects, pastoral nymphs and doe-eyed peasants. A friend to tradition and conservative taste, be it in his allusions to Raphael or Greuze, Bouguereau often worked on a grand scale in a highly refined and polished manner, favoring nude and semi-nude figures (coyly chaste but nonetheless erotic) depicted in a repertoire of gracefully studied poses. His slick manner was complemented by assured draftsmanship, fluid, almost invisible brushwork, and a cool palette that enhances the figures' luminous flesh tones.

The present work depicts a lovely young brunette, wearing a revealing chemise reminiscent of an antique chiton, delicately picking a butterfly from her shoulder. In conception and subject, it can be compared to the artist's *Cupid with a Butterfly* (1888, formerly Stern Collection). The butterfly, which emerges from the shroud-like chrysalis, is a time-honored symbol of the soul and resurrection. *Girl with a Butterfly* is a good example of the highly refined, unapologetically romantic, indeed achingly sentimental art that made Bouguereau so popular in the nineteenth century and such an easy target of champions of modern art in the twentieth. His precious nymphs and timeless shepherds were an anathema to those who championed the subject matter and emotional candor of modern life. Yet in the late twentieth century, Bouguereau and other nineteenth-century painters (one thinks of Pierre Puvis de Chavannes and Frederick Edwin Church), once dismissed as academic and operatic, again were the subjects of monographic exhibitions and studies. It is a testament to the surprisingly cyclical nature of

taste that both Audrey Flack and Andy Warhol owned paintings by Bouguereau and he is now one of the most expensive and sought-after artists of his age.

Alfred Thompson Bricher
(Portsmouth, NH 1837–1908 New Dorp, NY)
Morning at Narragansett, 1874
Signed and dated l.r. *A. T. Bricher 1874*
Oil on canvas, 17 x 31 3/4 in. (43.2 x 80.6 cm)
Private Collection

Provenance: Alfred T. Bricher; Sold through Inter-State Industrial Exposition of Chicago, 1874–1875 or Cincinnati Industrial Exposition, 1875, or Gill's Art Galleries, Springfield, 1878; The Braink Family, Providence, R.I.; Mr. and Mrs. John Payson, Hobe Sound, FL; D. Wigmore Fine Art, Inc., New York; Private Collection, Greenwich, CT.

Literature: Jeffrey R. Brown with Ellen W. Lee, *Alfred Thompson Bricher, 1837–1908*, exh. cat. (Indianapolis: Indianapolis Museum of Art, 1973); John Wilmerding, *American Light: The Luminist Movement, 1850–1875*, exh. cat. (Princeton: Princeton University Press, in association with the National Gallery of Art, Washington, D.C., 1989); Elizabeth Mankin Kornhauser, *American Paintings Before 1945 in the Wadsworth Atheneum* (New Haven: Yale University Press, 1996), pp.132-134.

A second-generation Hudson River School landscapist, Alfred Thompson Bricher devoted over forty years to depicting the natural splendor of the New England coastline. His attachment to the sea is hardly surprising, given a childhood spent in the ocean-side town of Newburyport, Massachusetts. While working in business, he studied at the Lowell Institute in Boston from 1851 to 1858, and there was exposed to the work of marine painters Fitz Hugh Lane and Martin Johnson Heade (q.v.). When Bricher began painting his own landscapes in 1856, his work clearly showed the influence of their Luminist compositions.

After finishing his studies, Bricher opened a studio in Boston and spent the first years of the 1860s painting sites popular with the Hudson River School. In New Hampshire's White Mountains he sketched and studied with the likes of Albert Bierstadt and William Morris Hunt, experimenting with their techniques and styles. However, Bricher's true love was the sea, and after painting his first shore subject in 1864 he began devoting his summers to sketching the coastal scenery of Chatham, Cape Cod, and Narragansett, Rhode Island, the site of the present work. These paintings often reflect the quiet repose and gentle harmony of summers along the shore.

Morning at Narragansett is the result of sketches made in June or July 1871 at Narragansett Pier. It is typical of Bricher's seascapes, which often involve unusually wide canvases and a strong horizon line in the lower half of the composition. A small fragment of beach in the foreground curves to create a natural cove, in which successive lines of waves break against the shore. The epitome of Bricher's confident and detailed brushwork, these waves seem to leap from the page, their forward progress barely hindered by the restraints of paint and canvas. Luminist details add a sub-

dued grandeur to the rolling clouds, while Bricher's characteristic attentiveness to local color highlights rocks and seaweed on the shore below. A sketchbook from 1871 contains a drawing identifying the two young girls at the right of the painting as Miss Helen Calder and Miss Anna Boynton. Bricher used these two little girls in similar poses in at least two other works: *Morning at Narragansett Beach, the Turn of the Tide* (1871; private collection), and *Indian Rock Narragansett Pier* (1873; private collection).

Matilda Browne (Newark, NJ 1869–1947 Greenwich, CT)
Laurel, c.1913
Signed l.r. *Matilda Browne*
Oil on canvas, 23 1/2 x 30 in. (59.69 x 76.2 cm)
Collection Susan G. and James T. Larkin

Provenance: Estate of Arthur Melrose Morse, Falmouth, Mass.; Robert Gunn Gallery, Essex, Ct.; to present owner, 1993.

Literature: "Permanent Gallery Collection Greenwich Artists Hope," *Christian Science Monitor*, Oct. 18, 1913; Helen Comstock, "A Woman Animal Painter," *International Studio* 78 (Nov. 1923), pp. 129-31; Jeffrey W. Andersen and Barbara J. MacAdam, *Old Lyme: The American Barbizon* (Old Lyme, Ct.: Florence Griswold Museum, 1982), p. 35.

Matilda Browne was descended from the early settlers of Greenwich, where she lived from 1895 to 1947 except for a period in the 1920s and early 1930s when she and her husband, Frederick N. Van Wyck, divided their time between New York City and New Canaan. She was a charter member of the Greenwich Society of Artists and a regular participant in their exhibitions, beginning with the first, in 1912, which was also the first ever held at the Bruce Museum. Browne's *August Morning* (c.1919) was among the Bruce's earliest acquisitions. In addition to her long involvement with the Cos Cob art colony, Browne was also affiliated with the group in Old Lyme, where she painted periodically in c.1905–1906 and again between 1911 and 1924. She was the only female member of the Old Lyme art colony to be taken seriously by her male colleagues. Evidence of her special status endures in the Florence Griswold House, where hers is the only door panel painted by a woman. She is also the only woman included in Henry Rankin Poore's caricatural painting over the dining-room fireplace, *The Fox Chase*, in which she is depicted throwing up her hands in shock at the sight of Childe Hassam standing at his easel, bare to the waist.

Browne's work embraces the Barbizon, Impressionist, and Tonalist styles. She began her artistic training at the age of nine with informal lessons from her Newark neighbor, Hudson River School landscapist Thomas Moran. With his encouragement, she studied flower painting with Eleanor and Kate Greatorex. Soon, however, the young artist also developed an interest in depicting animals. As a teenager, she studied with the livestock painter Carleton Wiggins. She continued her training in Europe, enrolling in 1889 at the Académie Julian in Paris, where she studied under the Barbizon painter Jules Dupré. The following year she trav-

eled to Holland to study with the American animal painter Henry Bisbing and, no doubt, to see examples of the long Dutch tradition of cattle paintings.

Although she was perhaps best known as an animal painter – a specialty that prompted one critic to dub her "the American Rosa Bonheur" – Browne depicted flowers and gardens throughout her career. *Laurel* is, in effect, a living still life: a close-up, ground-level view into a clump of Connecticut's state flower. Painted in the dark tones characteristic of the Barbizon style, it is animated with lively brushwork, jewel-like hues and unctuous impasto. This work may be the one that was first seen at the Bruce in the 1913 exhibition of the Greenwich Society of Artists. In a review of that show, the *Christian Science Monitor* critic called Browne's "painting of the laurel . . . particularly successful."

Gustave Caillebotte (Paris 1848–1894 Gennevilliers)
A Garden with Fruit Trees in a Landscape, 1882
Signed l.l. *Caillebotte*
Oil on linen, 24 3/4 x 20 1/2 in. (62.9 x 52.1 cm)
Private Collection

Born to a wealthy Parisian family, Caillebotte was both a promoter of and an original contributor to the Impressionist movement. He not only advocated and collected his fellow Impressionists' works but, like them, painted images of suburban middle-class leisure and recreation, such as boating at Argenteuil, where he settled in 1880. Caillebotte also produced lush landscapes and garden scenes like the present work. Rarer but no less original are his unconventionally designed still lifes. Caillebotte is probably most famous, however, for his carefully composed images of the emerging modern urban environment – the new Paris only recently created by Baron Haussmann – with its broad boulevards and metal-trussed bridges supporting fashionably dressed yet anonymous figures promenading, or faceless workers refinishing floors in elegant apartments. His art thus offers many parallels with the Naturalist literature of the time and often seems to anticipate twentieth-century art.

Caillebotte rarely employed the staccato, broken brushwork of Monet or the wispy veils of transparent color favored by Renoir. His brushwork is more controlled and usually more opaque. Further, unlike his colleagues who painted *alla prima* and *en plein air*, he often composed his pictures very deliberately using traditional studio practices such as preparatory drawings which he might even square for transfer and apply to a canvas that had already been geometrically composed with such ordering principles as the golden section. Thus it is somewhat surprising to discover a freely executed painting such as the present work, which appears to have been painted in the open air in one session. Apparently an unpublished work, it does not appear in the standard literature (see Marie Berhaut, *Caillebotte, sa vie et son oeuvre* [Paris, 1978] and A. Distel, *Gustave Caillebotte* [exh. cat. London, Royal Academy, 1996]) and its site has not been identified; however it resembles other landscapes painted on an upright format with a relatively free touch, such as the *Chemin de la Villa des Fleurs, Trouville* of 1883 (see Berhaut 1978, nos. 233 & 234).

Follower of Joos van Cleve (Cleves c.1485–1540/41 Antwerp)
Madonna and Child
Oil on panel, 29 1/2 x 22 1/2 in. (75 x 57 cm)
Collection Seena and Arnold J. Davis

Provenance: Gustave Wallace, Caracas; Sale New York (Christie's), June 6, 1984.

Exhibited: St Petersburg, FL, *The Seena and Arnold Davis Collection* (also shown at the Queens Museum, Flushing, N.Y., 1968).

The present work is a variant of a lost composition by the influential Early Netherlandish painter, Joos van Cleve, known through numerous studio copies and later replicas (see Max J. Friedländer, *Early Netherlandish Paintings*, vol. IXa [revised ed., New York, 1972], no. 63a-c, e, i & k; and the versions in the following sales: Sale New York (Christie's), June 7, 2002, no. 78; October 15, 1992, no. 42; October 7, 1993, no. 70; May 21, 1992, no. 110; January 11, 1991, no. 65; and London (Christie's), October 29, 1999, no. 26). The authority on Joos van Cleve, John Hand, ("Joos van Cleve: The Early and Mature Paintings," Ph.D. diss., Princeton University, 1978) found no fewer than twenty three replicas of the design and confirms (private communication July 2002) that the original is lost. The figures of the Madonna and Child in the center of the composition were based by Joos van Cleve on a lost drawing by Leonardo da Vinci, which is known through a Giampietrino painting formerly with Rob Smeets, Milan.

The present work is of special interest because it appears to be by a later artist, perhaps working in the third quarter of the sixteenth century, who was influenced by the harder, more enameled and decorative style of the Antwerp Mannerists. This anonymous master seems to have had a gift for decorative ornament. The painting includes a very different background from other replicas, most of which include a landscape viewed through a window in left-hand distance. In the present work that view is replaced with an elaborately conceived architectural vista, with a lunette depicting Cain killing Abel (traditional representatives of the sins of the Old Testament), a frieze of *putti* playing musical instruments and drawing a cart, and below, a view to the west façade of a cathedral with a statue of the Virgin and Child, two angels in the portal and two women. The latter are probably Mary and St. Elizabeth enacting the Visitation, when the two women, pregnant respectively with Jesus and St. John the Baptist, met before the church.

In place of the cherries that the Christ Child holds in most versions, he holds the crystal scepter and orb of his heavenly kingship, while the Madonna wears a diadem and headdress. To the right is a column decorated with a ram's skull and other ornaments. In the lower left-hand corner, there is an elaborately wrought and chased gold vase of flowers that does not appear in the other versions. Like the other details added by the artist, the seven blue columbine flowers in the vase are Christian symbols, alluding to the seven Sorrows of Mary.

Jasper Francis Cropsey (Rossville, NY 1823–1900 Hastings-on-Hudson, NY) *Beach at Bonchurch, Isle of Wight*, 1859 Signed and dated l.r. *J. F. Cropsey / Bonchurch / 1859*
Oil on canvas, 11 1/2 x 19 1/2 in. (29.2 x 49.5 cm)
Collection Mrs. John C. Newington

Exhibited: London, Royal Academy, 1860, as either *Sea Coast, at Bonchurch, Isle of Wight*, no. 479, or *Under the Cliff at Bonchurch, Isle of Wight*, no. 481; Washington, D.C., National Collection of Fine Arts, Smithsonian Institution, *Jasper F. Cropsey 1823–1900*, 1970–1971 (William S. Talbot, Smithsonian Institution Press: Washington, D.C., 1970), pp. 32-33, 81, cat. no. 26, ill. p. 60, also at Cleveland Museum of Art and Munson-Williams-Proctor Institute, Utica, NY.

Literature: William S. Talbot, *Jasper F. Cropsey, 1823–1900* (New York: Garland Publishing, Inc., 1977), p. 715, ill., fig. 4; Ella M. Foshay, "Jasper F. Crospey: Painter," in *Jasper F. Cropsey: Artist and Architect* (New York: The New York Historical Society, 1987), p. 27; Nancy Hall-Duncan, *A Man for All Seasons: Jasper Francis Cropsey*, exh. cat. (Greenwich, CT: The Bruce Museum, 1988).

Jasper Francis Cropsey taught himself to draw at a young age, sketching with youthful abandon in the margins of notepads and schoolbooks. These early experiments soon developed into real talent, and when thirteen-year-old Cropsey entered an architectural model in a New York contest, he won first prize and the notice of local architect Joseph Trench. Trench offered Cropsey an apprenticeship in his firm, and soon realized the artistic potential of his young student. He provided studio space, supplies and encouragement while Cropsey improved his technique. Eventually, the young artist moved on to study watercolor with the Englishman Edward Maury.

Cropsey's devotion to landscape began early and remained a lifetime commitment. His own religious convictions greatly influenced the way he approached his art, for he believed that nature was a manifestation of the divine, and thus should be depicted as accurately as possible. This belief, paired with a love of allegorical landscapes, attracted the young artist to the work of Thomas Cole. The leader of the Hudson River School, Cole was profoundly influenced by Transcendentalism (which had its roots in late-eighteenth- and early nineteenth-century German philosophy and art), and worked on the premise that landscape painting was synonymous with moral instruction. He painted idealized and highly detailed scenes that recalled the compositional devices of Claude Lorrain and Gaspard Poussin, and Cole's influence remained with Cropsey throughout his career.

A trip to Europe in 1847–1849 established Cropsey's reputation as one of the leading American landscapists. Upon returning to the United States, he completed several literary and allegorical works and spent time painting the Northeastern lakes, mountains, and valleys frequented by the Hudson River School. Sketching trips formed the foundation for Cropsey's finished works, and he remained committed to them throughout his career. Almost all of his paintings are based on sketches and drawings done on site,

recorded in detail and notated.

As the 1850s dawned, American artists began moving away from idealized to more naturalistic scenes, and by the end of the decade Cropsey had turned from his allegorical subjects to paint pure landscapes. The impetus for this change occurred during an extended stay in England from 1856 to 1863, where he studied the paintings of Constable, Turner, and the Pre-Raphaelites. He also devoted much of his time to depicting the English scenery. His Isle of Wight pictures, created mainly in the summer of 1859, were well received by British audiences. Cropsey did a number of paintings in and around Bonchurch, a town on the southeastern coast of the Isle. This particular piece pictures the sunny, rugged landscape of the coast. The low viewpoint, combined with the fine-tuned detail of objects like the anchor in the foreground, create a feeling of intimacy and familiarity. In his discussion of this painting, William Talbot commented, "The peaceful sunlight and attention to picturesque detail in this small oil may owe something to Constable's *Marine Parade and Chain Pier, Brighton*, 1827 (Tate Gallery, London), although the simple clarity and rugged aspect of reality also are reminiscent of contemporary Barbizon landscape painting" (Talbot, exh. cat., p. 33).

Jasper Francis Cropsey (Rossville, NY 1823–1900 Hastings-on-Hudson, NY) *Anne Hathaway's Cottage*, 1863 Signed and dated l.r. *F. Cropsy 63*
Oil on canvas, 21 1/2 x 38 1/2 in. (54.6 x 97.8 cm)
Collection Mrs. John C. Newington

Literature: Refer to previous entry.

In 1856 Jasper Francis Cropsey traveled to England, where he painted for eight years before returning home. He devoted much of his time to work on commissions from American collectors who, influenced by the decline of realism and the rise of Luminism, sought compositions that celebrated landscape's more romantic aspects. In the hamlet of Shottery near Stratford-on-Avon, Cropsey discovered an inviting cottage scene perfectly tailored to such requests. As was his custom, he first sketched and painted the site from a number of different angles, creating sketches which he later used as references for his larger finished paintings. He completed the present piece fifteen years after his visit with the aid of such studies (see *Study of Anne Hathaway's Cottage*, 1859; Newington Cropsey Foundation).

It is interesting to note the differences between studies and the finished piece; Cropsey maintained the vantage point but widened the perspective. The two figures at the left, originally in the center foreground, have been pushed closer to the edge of the composition, as has the man tending the sheep. This change makes the figures more peripheral to the work as a whole, creating instead a composition in which the main subject is the cottage itself. Cropsey had a long-standing interest in architecture, stemming from a childhood fascination with structural design and detail; throughout his career, he frequently accepted architectural commissions. In this work, his attention to building and design is quite evident in the painstakingly realistic detail of the cottage. Characteristic of his later work, *Anne Hathaway's Cottage* exemplifies the intense colors and ener-

getic brushwork for which Cropsey became best known.

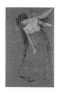

Edgar Degas (Paris 1834–1917 Paris)
Study of a Woman Standing, 1875
Gouache on brown paper with pastel,
18 1/4 x 11 1/4 in. (47.4 x 30.3 cm)
The Walter and Molly Bareiss Family Collection
of Art

Provenance: Otto Gerstenberg, Berlin; Richard Zinsel, New York.

Exhibited: Munich, Neue Staatsgalerie, *Sammlung Walther Bareiss*, 1965, p. 25, pl. 4; Kassel, Staatliche Kunstsammlungen, *Sammlung Walther Bareiss*, Summer 1967, p. 15, pl. 4; New York, Metropolitan Museum of Art, *European Drawings from the Bareiss Collection*, June 1969; Tübingen, Kunsthalle, and Nationalgalerie, Berlin, Edgar Degas: *Pastelle, Ölskizzen, Zeichnungen*, 1969, no. 74.

Literature: "European Drawings from the Bareiss Collection," *Metropolitan Museum of Art Bulletin*, vol. 27, no. 19 (June 1969), p. 438, ill.; Philippe Brame and Theodore Reff, *Degas et son oeuvre. A Supplement* [to Paul-André Lemoigne, *Degas et son oeuvre*, (1946-49)], (New York, 1984); Susan Sidlauskas, "Resisting Narrative: The Problem of Edgar Degas's *Interior*," *The Art Bulletin*, vol. LXXV, no. 4 (December 1993), p. 676, fig. 5.

The most accomplished draftsman of all the Impressionists, Edgar Degas often made preparatory drawings in the classical fashion in the preparation of his paintings. The present work had been thought to be a study for his painting traditionally, although incorrectly, called *The Rape (Le Viol)* (Henry McIlhenny Collection, Philadelphia Museum of Art). A dramatically conceived early work by Degas of c.1868-69, the final painting, often called simply *Interior*, depicts a man leaning against a wall in shadow and a woman, seated and slumped forward, with her back to him, in a darkened interior with a bed and table lit only by lamplight. As Theodore Reff first observed, the painting's literary source seems to be Emile Zola's *Thérèse Raquin* (T. Reff, *The Artist's Mind* [New York, 1976], p. 205). In the story, Zola describes the wedding night of Thérèse and her lover, Laurent, who have murdered her first husband and waited over a year to marry, to avoid arousing suspicion. Now they realize that their tormented consciences will not allow them any intimacy, but will eventually drive them to despair and suicide. However, not all the details of the painted scene correspond to the narrative of the text.

While the woman in the present drawing seems to be the same model and wears the same costume, a white chemise that slips off one shoulder, her standing pose is very different, prompting Brame and Reff (1984) to hypothesize that the drawing was for another composition that was never executed. Still another drawing that may be part of a series of related studies depicts a woman bending forward and nude to the waist, her arm again outstretched but lower than in the present work (Öffentliche Kunstsammlung, Kunstmuseum, Basel). Conceivably, both drawings represented a presumably earlier conception of the narrative. Several writers have discussed Degas's famous misogyny in relationship to

his images of male-female confrontation (see N. Brouda, "Degas's Misogyny," *The Art Bulletin*, LIX, March 1977, pp. 95-96). And others have commented on the modernity of Degas's final painting and its enigmatic, "narrative incoherence" (Susan Sidlauskas, "Resisting Narrative: The Problem of Edgar Degas's *Interior*," *The Art Bulletin*, vol. LXXV, December 1993, pp. 671-696). Whatever his final narrative intent, we may marvel at the artist's intelligence as revealed in the masterful economy with which he lends movement to the woman in the drawing with only a few rapid strokes of the brush. In trying to decipher these clues to the conception of the final narrative of the design, we recall that Degas remarked that composing a picture is like plotting the perfect crime.

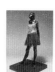

Edgar Degas (Paris 1834–1917 Paris)
Petite Danseuse de Quatorze Ans (Little Fourteen-Year-Old Dancer)
Bronze, muslin and satin with a wood base,
37 1/2 in. high (95 cm)
Private Collection

Provenance: Hébrard Family, Paris; Galerie Marcel Bernheim, Paris; Gallery of Ancient and Modern Art, Schaan; Marlborough-Gerson Galleries, New York; Norton Simon, Pasadena; his Sale New York (Sotheby's), May 5, 1971, no. 29; Mr. And Mrs. Jack Linsky; Mrs. Belle Linsky; her Sale New York (Sotheby's), May 10, 1988, no. 14, ill.; with Stephen Mazoh & Co., Rhinebeck, N.Y.

Literature (selected): Paul Mantz, "Exposition des oeuvres des artistes indépendants," *Les Temps*, 1881, p. 3; Jules Claretie, *La Vie à Paris*, 1881; Joris Karl Huysmans, *L'Art Moderne* (Paris, 1883), pp. 226-227; John Rewald, *Degas: Works in Sculpture – A Complete Catalogue* (New York, 1944), pp. 6-8, 14, 15, 63, 69, no. XX (another cast); Sara Campbell, "Degas, The Sculptures: A Catalogue Raisonné," *Apollo*, August 1995, pp. 46, 47 (with illustration of another cast and the wax); Martine Kahane, Delphine Pinasa, Wilfride Piollet and Sara Campbell, "Enquête sur la *Petite Danseuse de quatorze ans* de Degas," *La revue du Musée d'Orsay*, no. 7 (Paris, Autumn 1998), p. 71, no. 19, ill. (another cast and the wax).

Of the approximately 150 sculptures that Degas executed in his lifetime, the original wax for *Petite Danseuse* was the only one that he ever exhibited. Originally planned to be exhibited in the Fifth Impressionist Exhibition in 1880, it was only completed in time to be shown in the Sixth the following year. The original wax (Collection of Mrs. Paul Mellon, Upperville, VA) was executed between c.1879 and 1881 in wax, wire and hemp and was dressed in real fabrics – grosgrain silk faille for the bodice, tulle and gauze for the tutu, fabric slippers and a satin hair ribbon. Even a wig was provided, although this was subsequently covered with a thin layer of wax, as were the slippers. Ten years after Degas's death, a series of bronzes, of which the present work is one, were cast of the figure by the foundry of A.A. Hébrard.

It is difficult today, when this charmingly diminutive three-quarter-life-size image has become one of the most beloved of all nineteenth century sculptures, to imagine the

horror with which it was originally received. Its realism, made all the more unsettling in the clothed wax original, shocked and appalled contemporary critics as much as any work by Rodin. Paul Mantz found it "terrifying . . . with bestial effrontery she moves her face forward, or rather her little muzzle . . . This poor little girl is the beginning of a rat . . . The bourgeois admitted to contemplate this wax creature remain stupefied for a moment and one hears fathers cry: God forbid my daughter should become a dancer." Jules Claretie was more generous, admiring the figure's insouciance and describing her as an exercise in "a strangely attractive, disturbing and unique naturalism." The critic and novelist J. K. Huysmans was most observant, noting that "the astonished public flies [from the sculpture], as if embarrassed. The terrible realism of this statuette makes the public distinctly uneasy; all its ideas about sculpture, about cold lifeless whiteness, about those memorable formulas copied again and again for centuries, are demolished. The fact is that on the first blow, M. Degas has knocked over the traditions of sculpture, just as he has for a long time been shaking up the conventions of painting. At once refined and barbaric with her busy costume and her colored flesh, lined with the work of its muscles, this statuette is the only truly modern attempt I know in sculpture."

Although the figure seems to be caught in a momentary, unself-conscious pose – her back arched, her arms entwined behind her, her face raised slightly and extended forward – it was the result of numerous preparatory drawings and at least one smaller study in wax. The model for the *Danseuse* was Marie van Goethern, the daughter of a Belgian laundress and tailor, who turned fourteen in 1878 and together with her two sisters was a ballet student at the Opéra. During the 1880s Marie became a well-known artist's model, a *habitué* of cafés and brasseries and a member of the *demimondaine*. In trying to parse the public's original outrage, it is useful to recollect that unlike today, when ballet school is a badge of the privileged, these young dancers were referred to as the "rats" of the Opéra, often coming from lower or working class families. In the same exhibition in which Degas exhibited the original wax, he also showed two portraits of well-known murderers, as a kind of physiognomic study of the criminal type, thus further unsettling the critics with his exposure of a darker side of Parisian life. The year 1881 is regarded by Degas scholars as the high-water mark of the artist's realism.

 Battista Dossi (Ferrara c.1495–1548 Ferrara) *The Four Seasons with Signs of the Zodiac*
Oil on cedar panel, 3 x 10 1/2 in. (7.7 x 26.5 cm)
Collection Richard L. Feigen, New York

Provenance: Private Collection, Europe; Private Collection, New York.

Exhibited: London, Walpole Gallery, *Treasures of Italian Art*, 1988, no. 2 [as Dosso Dossi].

Literature: A. Ballarin, *Dosso Dossi: La pittura a Ferrara negli anni del ducato di Alfonso I* (Cittadella, 1994-95), vol. I, p. 322, no. 403; vol. II, fig. 568 [as Battista Dossi].

Recorded as a member of Raphael's workshop in Rome in 1520, Battista Dossi was the younger brother of Dosso Dossi and by the end of the decade was back in Ferrara in his brother's shop. Purportedly of a difficult disposition and deformed, he only communicated with his brother in writing. The distinction between the two brothers' styles has been much debated; typically, the present work has been attributed to both Dosso and Battista. After Dosso's death in 1542, Battista received important commissions from Duke Ercole II and Laura Dianti, the former mistress of Duke Alfonso.

In this charming little painting we encounter the squat but animated figure type and strong saturated palette for which the Dossi brothers are admired. We also witness their creative approach to subject matter within established themes. Among allegorical subjects, the Four Seasons, with the Five Senses and the Elements, was one of the time-honored themes in Renaissance art. Here the Seasons are depicted by the personification of Spring, leaning over a basket of flowers; Summer, a ripe nude, holds a sheaf of wheat in her hand; Autumn picks grapes from a vine; while Winter, on the extreme right, is personified in traditional fashion as an old man wrapped in a cloak warming himself over a fire. At the center is a globe with a sash with the signs of the Zodiac and Apollo's quadriga. The small scale and long horizontal format of the panel suggest that it may have once been a decorative panel in a cabinet or piece of furniture.

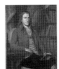 **Ralph Earl** (Shrewsbury, MA 1751–1801 Bolton, CT)
Portrait of Thomas Shaw, 1793
Oil on canvas, 42 7/8 x 32 7/8 in.
(107.2 x 82.2 cm)
Private Collection

Literature: Elizabeth Mankin Kornhauser, with Richard L. Bushman, Stephen H. Kornhauser, and Aileen Ribeiro, *Ralph Earl: The Face of the Young Republic*, exh. cat. (New Haven: Yale University Press, 1991), p. 53, 55; Laurence B. Goodrich, *Ralph Earl: Recorder For an Era* (New York: The Research Foundation of The State University of New York, 1967); Elizabeth Mankin Kornhauser, *American Paintings Before 1945 in the Wadsworth Atheneum* (New Haven: Yale University Press, 1996), p. 336-344.

Born into a Massachusetts farming family, Ralph Earl abruptly ended his early artistic career when criticism of his Tory sympathies forced him to flee to England during the first years of the American Revolution. His sojourn in London proved fruitful, however, as it allowed him to perfect his technique through direct study of the works of Benjamin West, Thomas Gainsborough and Sir Joshua Reynolds. After returning to the United States Earl settled in New York City, but left in 1788 to paint for ten years in Connecticut. Though these years proved to be his most successful, the decision caused Earl's career to diverge dramatically from those of his contemporaries. While Charles Wilson Peale, John Trumbull and Gilbert Stuart painted at the center of American political life, Earl depicted a population largely overlooked by other artists. In fact, his own roots in Worcester County enabled Earl to better understand the modest tastes of his conservative Connecticut subjects. To

suit them he modified his portrait style, simplifying his technique and abandoning the aristocratic imagery and pastel colors of his London and New York portraits. He favored instead bright primary colors, particularly the reds and greens so prominent in the present work. He also chose to use the antiquated full-length format still preferred in Connecticut, rather than the bust-style portraits so popular in urban centers.

Many of Earl's Connecticut sitters fought for the patriot cause during the Revolution. Among them was the Shaw family, residing in the port town of New London. Thomas Shaw (1739–1795) and his brother Nathaniel had directed Colonial naval operations from the family home on New London harbor during the war. The house itself was greatly damaged during the raid on Long Island in 1781, and Thomas commissioned six portraits of various family members in 1792 and 1793, following its renovation. Locally made furnishings, like the armchair in the present work, decorated the repaired home, and Earl refers to the pride the family felt in its regional identity by including such objects in his portraits.

Earl painted frankly realistic compositions while in Connecticut. *Portrait of Thomas Shaw* is a prime example of the literal interpretations his sitters appreciated; Earl candidly avoids flattery, highlighting Shaw's prominent nose and large forehead with direct light. The artist treats his subject with restraint, using broad, linear brushwork (as opposed to the quick, short strokes of his English works) to denote Shaw's sober costume and indifference to fashion. Yet he adds a hint of subdued majesty by painting Shaw before rich red drapery, a common device in British portraiture to enhance a subject's importance. According to Elizabeth Kornhauser, this is a second version of Earl's portrait of Thomas Shaw. The first (1793; New London County Historical Society, CT) pictures Shaw in a similar pose, but seated in front of a window that affords a view of one of his ships in New London harbor. Fort Trumbull lies beyond the water, flying an American flag (Kornhauser, 1991, p. 55 ill., fig. 1.33). Earl often observed the historical significance of the period by alluding to patriotic endeavors in his portraits; the window view is a reference to the role the Shaw homestead played in the Revolution.

Bartolo di Fredi (died 1410 Siena)
Adoration of the Magi, c.1375
Oil on panel, 14 x 8 3/4 in. (35 x 21.9 cm)
The Phillips Family Collection

Provenance: S. Bardi, Florence; J. Pierpont Morgan, New York; Private Collection, Holland; R. Critchley, Albury; with Anthony Speelman, London.

Literature: Bernard Berenson, *Central and North Italian Schools* (London, 1968), p. 29 (as Bartolo di Fredi); G. Freuler, *Bartolo di Fredi Cini. Ein Beitrag zur sienesischen Malerei des 14. Jahrhunderts* (1994), p. 506, no. 99, fig. 408, p. 507 [as Bartolo di Fredi School (Schule)].

Bartolo di Fredi was the most distinguished painter in Siena in the second half of the fourteenth century. He is first recorded as sharing a studio with Andrea Vanni in 1356. During the following decade, he executed frescoes in San Gimignano, had commissions in Volterra in the 1370s, and in the 1380s painted altarpieces and frescoes in Montacino. However, throughout his life he was primarily active in Siena. He painted until his death in 1410.

The attribution to Bartolo di Fredi of this work was first proposed by Bernard Berenson (published in 1968). John Pope Hennesey suggested in a letter in 1982 to the present owner that it was by Andrea di Bartolo, while Freuler (1994) most recently has suggested that it is by an artist working in Bartolo di Fredi's studio. Complimentary of its quality, he allowed that it had nothing of the "artistic decadence" of the other anonymous *Kleinmeister* active in the artist's circle and studio. However, his suggestion that the painting could be by the same hand as a small Madonna in the Wallraf-Richartz Museum in Cologne (cat. 745; Freuler fig. 409) is implausible. That work is not of the same quality as the present painting. The latter, however, compares favorably to Bartolo di Fredi's other larger altarpieces of the Adoration of the Magi in the museum in Siena (Freuler, cat. 60) and in the Robert Lehman Collection in the Metropolitan Museum of Art, New York, no. 1975.16 (see John Pope Hennessy and Laurence Kanter, *Italian Paintings in the Robert Lehman Collection*, [1987], no. 13, ill.). Though much larger (149 x 86 cm), the Lehman painting is similar in design to the present work, featuring an upright composition with the Virgin and Child seated on the right in a marble tabernacle with canopy, as the Magi and their retinue approach from the left. Some details are very similar, such as the tall white horse with beautiful arching neck at the back; but all of the poses of the kings and their attendants, as well as the architecture, are very different, although no less creatively rendered in fine detail. Scarcely a copy, the present piece may be an autograph work that is preparatory to the Lehman picture. It is probably cut slightly on the left, where the figures are tightly cropped, but the condition of the paint film is good and its delicate punch work well preserved. Note, too, the incised lines with which the artist has drawn the architecture.

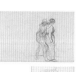

Vincent van Gogh (Zundert 1853–1890 Auvers-sur-Oise)
A Double Sided Sketchbook Page – A Still Life with Can, Wineglass, Bread and Alum; Two Women and a Girl
Pencil and black chalk on paper,
10 1/2 x 17 1/4 in. (26.7 x 43.7 cm)
Collection Toni and Ralph Wyman

Provenance: Paul Ferdinand Gachet, Auvers, 1890–1909; Paul Gachet, Auvers; Wildenstein & Co., New York; Sale London (Sotheby's), June 22, 1966, no. 4; with Richard Feigen, New York; Sale New York (Sotheby-Parke Bernet), October 23, 1980, no. 304, ills.

Exhibited: New York, Wildenstein & Co., *Vincent van Gogh Loan Exhibition*, March–April 1955, no. 109; New York, E.J. Wisselingh & Co., *French Paintings of the XIXth and XXth Centuries*, November–December, 1956, no. 80; New York, Wildenstein & Co., *Drawings by the Masters*, October 1960, no. 80.

Literature: J.B. de la Faille, *The Works of Vincent van Gogh* (1970), no. 1650, ills; Jan Hulsker, *The Complete Van*

Gogh. Paintings. Drawings. Sketches (New York, 1977), no. 2073, ill; J.B. de la Faille, *Vincent van Gogh, The Complete Works on Paper*. Catalogue Raisonné, vol. 1 (San Francisco, 1992), pp. 431–432, no. 1650, and vol. 2, pl. CCXLII.

The famous Post-Impressionist Vincent van Gogh drew and painted copiously and at high speed during his tragically brief career. Often short on supplies, he frequently covered his sketching paper, sometimes on both sides, with numerous quick, preparatory studies and ideas recorded in pictorial shorthand; sometimes, as in the present work, he added color notes to himself. This drawing is typical of these crowded sheets, featuring numerous unrelated sketches, possibly executed at different dates. As early as 1928, J.B. de la Faille, the author of the artist's catalogue raisonné, related this sheet to the still life painting and a related drawing of *A Death's Head Moth on an Arum* now in the Rijksmuseum van Gogh, Amsterdam (de la Faille no. 610). Vincent mentions the Amsterdam drawing in a letter to his brother Theo written from Auvers-sur-Oise in May of 1890, in which he marvels at the size and colors of this splendid creature of the night. It also seems to relate to *Arum*, likewise in the Rijksmuseum van Gogh (de la Faille no. 1613). The studies of the two women on the verso as well as the girl on the recto may have been added at a later time.

While probably never regarded by the artist as a finished work of art to be displayed, it is of interest for its record of van Gogh's creative process and for capturing at its inception something of the teeming energy that enlivens his art. The history of the work's ownership is also of interest: like many of van Gogh's works, it was owned by Dr. Gachet, who not only became a close friend in Auvers and treated Vincent for his mental illness but also was the subject of the portrait by van Gogh that still holds the record for the sale of any painting at public auction.

Armand Guillaumin (Paris 1841–1927 Crignon)
Landscape in Crozant in the Creuse Valley
Signed l.r. *Guillaumin*
Oil on canvas, 23 5/8 x 28 3/4 in. (60 x 73 cm)
Private Collection

Provenance: Collection Kahan, New York.

Literature: Raymond Schmit, *Armand Guillaumin (1841 – 1927). Catalogue raisonné de l'oeuvre peint* (catalogue by G. Serret and D. Fabiani) (Paris, 1971), no. 642, ill.

Born the son of a tailor to the sporting crowd but on the Rue de Rivoli within sight of the Louvre, Guillaumin was among the first generation of the Impressionists. He studied at the Académie Suisse, became close friends with Cézanne and Pissarro as well as Renoir and Monet (qq v), and exhibited in the Salon des Refusés as early as 1863. His early works have the divided light and color as well as the heightened tonality and bright palette of the Impressionists. Like them, he embraced the practice of painting *en plein air* and appeared in six of the eight Impressionist exhibitions. Guillaumin knew little professional success as an artist early in his career, living very simply and supplementing his income with a civil service job in the *Administration des Ponts et Chaussées*. It was only after he suddenly received 100,000 gold francs for a bond he held in 1891 that he could retire and devote himself exclusively to painting.

In the previous decade he had become acquainted with a younger generation of artists, including Gauguin, van Gogh, Seurat and Signac, and adopted a vigorously rough style of painting sometimes comparable to that of van Gogh and a more vibrant, even at times shrill palette that anticipates aspects of the color schemes of the Fauvists. While he had painted genre scenes, portraits and a few still lifes in his earlier career, after the financial fates shined on him in 1891, he devoted himself to landscape, above all that of the Côte d'Azur, Côte d'Argent and the Creuse Valley.

The present work depicts an autumnal landscape in Crozant and was probably painted in 1905. Guillaumin had first visited Crozant – a small village situated at the confluence of the Creuse and Sédelle Rivers – in 1892. Thus he followed Monet, who had made landscape painting excursions to the region a few years earlier. Both artists admired the Creuse Valley's open rolling hills, where at the time there were only a few trees and the agrarian economy was primarily based on sheepherding. They also both painted Crozant's steep gorges and ravines, and Guillaumin depicted the village's six windmills. Yet, whereas Monet's paintings of the Creuse Valley often stress its rugged bareness with a subdued, crepuscular, even melancholic palette, Guillaumin used brighter, more joyous colors and looser brushwork. His favorite time of the year to paint in Crozant was late summer and autumn. He usually spent his winters in Paris and also made regular painting excursions to Agay and Saint-Palais-sur-Mer, exploring a very different range of hue in the sunlight of the coast. Although Guillaumin was an aging artist of about sixty-four with health problems when he painted this work, he remained productive; Schmit (1971) lists no fewer than sixteen paintings that he executed in Crozant around 1905. The artist survived until 1927, dying at age eighty-six, the last of his generation of Impressionists.

Childe Hassam (Dorchester, MA 1859–1935 Easthampton, NY)
Indian Summer in Colonial Days, 1899
Signed and dated l.r. *Childe Hassam 1899*
Oil on canvas mounted on board, 22 x 20 in. (55.9 x 50.8 cm)
Collection Mr. and Mrs. Russell S. Reynolds, Jr.

Exhibited: Boston: Boston Art Club, *Second Exhibition and Competition of Colonial Pictures under the Auspices of the Colonial Dames of Massachusetts*, December 1899.

Literature: Patricia Jobe Pierce, *The Ten* (Concord, NH: Rumford Press, 1976), pp. 84–92; Susan G. Larkin, "The Cos Cob Clapboard School" in *Connecticut and American Impressionism*, exh. cat. (Storrs: The University of Connecticut, 1980), pp. 82–99, 162–163; Elizabeth Mankin Kornhauser, *American Paintings Before 1945 in the Wadsworth Atheneum* (New Haven: Yale University Press, 1996), pp. 444–448; Susan G. Larkin, *The Cos Cob Art Colony*, exh. cat. (New York and New Haven: National Academy of Design and Yale University Press, 2001), pp. 103–109, ill. p. 108, fig. 61.

Son of a Boston merchant, Childe Hassam demonstrated a childhood aptitude for drawing and experienced early success as a freelance illustrator. In the interest of developing his skill as a painter, he studied at both the Lowell Institute and the Boston Art Club, as well as privately with Munich-trained artist Ignaz Marcel Gaugengigl. Later, he continued this education with classes at the Académie Julian from 1886 to 1889, studying under Jules-Joseph Lefebvre and Gustave-Rodolphe Boulanger. However, Hassam soon abandoned many of the Académie's methods in favor of Impressionism, which he encountered in the works of Monet (q.v.), Sisley, and Pissarro (q.v.). He maintained his interest in the style upon returning to the United States in 1889, and quickly developed an Impressionist technique that was distinctly American in nature, characterized by his own personal style of representing light and color.

Though not a native of Connecticut, Hassam spent many years painting Cos Cob, the site of an Impressionist art colony established in about 1889–1890 by his friend John H. Twachtman. During periodic visits between 1894 and 1916 or 1917, Hassam painted numerous compositions, focusing many of his efforts on committing to canvas the details of Cos Cob's classic early-American architecture. Long interested in colonial buildings, he was inspired by the village's structures, and painted their images with careful attention to architectural detail and design. One mile from the Holley House, where Hassam boarded in Cos Cob, stood Putnam Cottage, the site of the present work. Local folklore linked the building with a famous event from the Revolutionary War (see Larkin, *Cos Cob Art Colony*, pp. 106-107), adding to its mystique and appeal for the artist. *Indian Summer in Colonial Days*, painted in 1899, was Hassam's second composition depicting the cottage. As in the first, he avoided painting the building's main façade, which, with its Victorian style, looked too modern for his tastes. Instead, he chose to picture the back of the house, which exemplified the colonial architecture he so admired, and which he carefully documented with details of its stone and clapboard siding.

The inclusion of costumed figures in the center of the piece is unusual in Hassam's oeuvre; Susan Larkin speculates that "his decision to include them was probably motivated by his plan to exhibit the painting at the *Second Exhibition and Competition of Colonial Pictures under the Auspices of the Colonial Dames of Massachusetts* at the Boston Art Club in December 1899," where he won second prize (*Cos Cob Art Colony*, p.109). Beyond these realistic architectural and costume details, Hassam's composition is dominated by his Impressionist influences. Reflected light and shadows play over the landscape, rendered in a muted palette of vivid greens and soft blues, yellows, and purples. Hassam employed typically Impressionist loose brushwork; the paint is unevenly applied across the canvas, its gaps suggesting, rather than asserting, the scene's boundaries.

Childe Hassam (Dorchester, MA 1859–1935 Easthampton, NY)
Spanish Ledges, 1912
Signed and dated l.l. *Childe Hassam 1912*
Oil on canvas, 22 1/4 x 24 in. (56.5 x 61 cm)
Collection Richard and Mary Radcliffe

Exhibited: Greenwich, CT, Bruce Museum, 1919; Greenwich, CT, Bruce Museum, *Art for the Great Estates: The Bruce Museum's First Decade*, 2001.

Literature: Patricia Jobe Pierce, **The Ten** (Concord, NH: Rumford Press, 1976), pp. 84–92; Warren Adelson, "Childe Hassam: An American Impressionist" in *Childe Hassam: An American Impressionist*, exh. cat. (New York: Adelson Galleries, 1999), pp. 6–7.

Like the French Impressionists, Childe Hassam often painted series of canvases that investigated one subject under varied atmospheric conditions. One of those series depicted the Isles of Shoals, remote islands off the coast of New Hampshire which Hassam first visited in the mid-1880s. Over the course of the next thirty years he periodically visited the site, creating watercolors and oils that explored the wilderness of the island's sparkling waters and rocky coast. Experimenting with techniques that emphasized a composition's expressive and emotional content, rather than its form or technique, his depictions are visually exciting, virtually palpitating with light.

The area in the present piece acquired its name from a Spanish ship wrecked against the island rocks in the early nineteenth century. *Spanish Ledges* is a model of Hassam's later Impressionist technique, which was characterized by a high-keyed palette and broken daubs of vivid color. The combination of these elements intensifies the reflection of light on the rocks and water. Hassam abstracted the landscape by simplifying its forms into flat patterns and shapes — like the elongated individual brushstrokes that make up the water — a technique possibly influenced by his third trip to France in 1897 and 1898, where he encountered the design principles of Post-Impressionism. Those new ideas, combined with later Modernist influences like the brushwork of Neo-Impressionism and the patterns of Nabi painting, influenced Hassam's stylistic development. His experiments pegged him as one of the most innovative of the American Impressionists, though at its core even his daring work remained true to its Impressionist foundation.

Martin Johnson Heade
(Lumberville, PA 1819–1904 St. Augustine, FL)
Sunlight on Newbury Marshes,
c.1865–1875
Signed l.l. *M. J. Heade*
Oil on canvas, 13 x 26 in. (33 x 66 cm)
Private Collection

Provenance: Marshall Field, Chicago; Private Collection, Indianapolis; D. Wigmore Fine Art, Inc., New York; Private Collection, Greenwich.

Literature: Theodore E. Stebbins, Jr., *Martin Johnson Heade* (New Haven and London, 1999) pp. 29-31; John Wilmerding, *Master Paintings from the Butler Institute of American Art*, ed. Irene S. Sweetkind (New York, 1994), p.113; Robert G. McIntyre, *Martin Johnson Heade, 1819-1904* (New York: Pantheon, 1948).

Although relatively unknown in his own day, Martin

Johnson Heade has been recognized in recent years as a remarkably innovative landscape painter and a key figure in luminism, the culminating phase of the Hudson River School. His artistic career embraced a wide variety of subject matter, from dramatic seascapes of the Eastern United States to lush images of South American orchids and humming-birds. However, Heade is perhaps best remembered for his landscapes of northeastern salt marshes, which account for nearly one-fifth of his *oeuvre*.

Born in rural Pennsylvania, Heade learned to paint from his neighbor, folk artist Edward Hicks. After traveling throughout Europe and America, he moved into New York's Tenth Street Studio in 1858, where he met Frederic Edwin Church and Albert Bierstadt. The move significantly changed Heade's art. He began to specialize in landscapes and still lifes, developing an individual approach to the style and practice of the Hudson River School. While other landscape painters of his era specialized in large-scale views of dramatic sites like the Rocky Mountains, Heade focused his attention on the more commonplace salt marsh, to which he had been introduced in 1859 by the naturalist Rev. James C. Fletcher. At the time, this was a new subject for the American painter, pioneering because it rejected, in the words of David Miller, the "high Romantic iconography . . . and aesthetic criteria" that underlay contemporary landscape painting (see Dark Eden, *The Swamp in Nineteenth-Century American Culture* [New York: Cambridge University Press, 1989], p.1).

The marsh, as John Wilmerding has noted, "is the one landscape in constant flux," its composition continually shifting from water to land (see Wilmerding, p. 113). Heade became a master at recreating on canvas the transitory feeling of a setting always on the verge of change. Arranging a limited number of images – a haystack, a cow, a tidal river – in different combinations, he explored the salt marsh at all times of day and in varying weather conditions. The intimacy of the scenes is achieved through an insistent accuracy of detail, prompting Thomas Stebbins to remark that "Heade painted the marsh in the way that Thoreau wrote of Walden Pond, describing every detail and every nuance of an area that to most seemed mundane and forgettable" (See Stebbins, p. 4).

The present work is typical of Heade's marsh views. The extended horizontal format emphasizes the plane of the picture, which is further underscored by a flat, low horizon line in the Dutch tradition. Heade's exquisitely controlled brushwork enlivens the mauve-colored sky, where the movement of the clouds echoes the rhythms of man and nature in the fields below. This sense of motion is enhanced by the haystacks, placed at carefully measured intervals to lead the eye through the composition. Some scholars have suggested the possible influence of French artist Gustave Courbet in Heade's marsh scenes. Yet this piece's smooth surface, coolly uniform light and tranquil waters also emanate a natural calm and order celebrated by the Transcendentalists and the Hudson River School.

Meindert Hobbema (Amsterdam 1638–1709 Amsterdam)
Village Scene, 1661
Oil on panel, 14 5/8 x 19 1/4 in.
(37 x 48.5 cm)

Collection Mr. and Mrs. Richard M. Thune

Provenance: A.N. Garland Collection, 15 Queen's Gate, London; his sale London (Christie's), Apil 25, 1903, no. 47 (410 gns to Gribble); with P. & D. Colnaghi, London; Sale Berlin, November 1906 (according to Broulhiet); Oscar Huldschinsky, Berlin, by 1906; Sale Berlin (Cassirer and Helbing), May 10, 1928, no. 14, pl. XI (DM 65,000 to Böhler); with Böhler, Munich; Leo van den Bergh, Wassenaar; his sale, Amsterdam (Mak van Waay), November 5–6, 1935 (fl. 12,000); Otto Wertheimer, Paris; Dr. Max Schmidheiny, Heerbrugg, Switzerland; Private Collection, England; with dealer Rob Noortman, Maastricht.

Exhibited: Berlin, Gräflich Redern'sches Palais, *Werke Alter Kunst aus dem Privatbesitz der Mitglieder des Kaiser Friedrich-Museum-Vereins*, January 27–March 4, 1906, no. 63, pl. 21; Rotterdam. Museum Boymans–van Beuningen, *Meesterwerken uit vier eeuwen 1400–1800*, June 25–October 15, 1938, vol. 1, p. 23, no. 90, vol. 2, p. 100, pl. 155, ill.

Literature: E. Michel, *Hobbema et les paysagistes de son temps en Hollande* (1890), p. 33, ill.; W. von Bode, *Collection d'Oscar Huldschinsky* (1909), no. 14; W. von Bode, *Meindert Hobbema* (1909); C. Hofstede de Groot, *A Catalogue Raisonné...*, vol. IV (1912), p. 396, no. 126; E. Michel, *Meindert Hobbema* (1927); G. Broulhiet, *Meindert Hobbema* (1938), p. 399, no. 178, p.191, ill.

Meindert Hobbema was one of the most accomplished of all the naturalistic Dutch landscapists, specializing in images of woodlands often with cottages, watermills and sandy roads. His early works (the earliest dated work is of 1658, Detroit Institute of Art) sometimes featured river scenes with slender trees that were influenced by Salomon van Ruysdael and woodlands reminiscent of those of Cornelis Vroom. But the clearest imprint on his art was made by Jacob van Ruisdael (qv), who testified in 1660 that Hobbema had been his apprentice for "some years." Somewhat surprisingly, Hobbema's greatest indebtedness to Ruisdael was only manifested two years later in his paintings dated 1662 (see as examples the paintings in the Louvre, Paris, the Philadelphia Museum of Art, and the National Gallery of Victoria, Melbourne), which include massive oak trees with compact contours and silhouetted trunks, lighting systems featuring artfully distributed patches of light, and a palette dominated by dark greens and earth hues.

By 1663 he had adopted a freer approach, with more open compositions, a lighter tonality, more colorful palette and more fluid touch. The present work features the form of his signature that Hobbema used only after 1660 ("*m hobbe-ma*") and is characteristic of his woodland scenes from c.1663–68 (compare Broulhiet 1938, nos. 179, 184–186, dated 1665), when he often depicted a glade with a still pond in the foreground, a sandy road retreating diagonally, a screen of trees arrayed across the middle distance, and cottages nestled in lighted clearings. This type of picture descends from Ruisdael's images of a pool at the edge of a forest painted in the mid-1650s (see, for example, the painting at Worcester College, Oxford), but Hobbema's are much

airier and more cheerful. Many of Hobbema's paintings from this period are much larger than the present work, but he also could create expansive images on this more intimate scale. If less majestic and powerful than the works of his teacher, Hobbema's landscapes express a view of nature that suggests pacific well-being. Even the staffage, here a charming glimpse of fishermen, reinforce this optimistic view of the world.

In 1668 Hobbema became one of the wine gaugers for the Amsterdam octroi, a post he retained for the rest of his life. His activity as a painter was probably sharply curtailed after he assumed his new job, but he did not entirely give up painting, as was once believed. Later works have been identified, some of high quality, including his famous *Avenue at Middleharnis* of 1689 (National Gallery, London). Broulhiet identified another painting as an autograph replica or study for the present work (see 1938, cat. 177, ill.), but it appears to only be a copy by another hand.

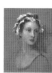

William Hogarth (London 1697–1764 London)
Miss Rich, also known as *A Charity Girl*, c.1730
Oil on canvas, 16 1/2 x 13 3/4 in.
(41.9 x 34.9 cm)
Collection Mr. and Mrs. Richard M. Thune

Provenance: Mrs. Hogarth to 1789; Mary Lewis, her cousin, 1789–1790; sold by her instructions at Greenwoods, April 24, 1790, lot 42 (Mrs. Hogarth's sale catalogue); W. Seguien, 1790; John Heywood, 1817; J. Hawkins, 1833; J. Heywood Hawkins, 1841–1867; C.H.T. Hawkins, 1896; Max Michaelis, cat. 1905, no. 9; Michaelis family, by descent; Sale London (Christie's), June 18, 1971, no. 69; with Edward Speelman, Ltd., London.

Exhibited: London, British Institution, 1817, no. 21; London, British Institution, 1844, no. 119; London, National Portrait Exhibition, 1867, no. 344; London, Burlington Fine Arts Club, 1907, no. 18; Paris, Cent Portraits, 1909, no. 11.

Literature: John Nichols, *The Genuine Works of William Hogarth*, 1810, vol. 2, p. 274; John Nichols, *The Genuine Works of William Hogarth*, 1818, vol. 3, pp. 171 and 197; J.B. Nichols, *Anecdotes of William Hogarth – written by himself*, 1833; Austin Dobson, *William Hogarth*, 1907, p. 219; Thieme–Becker, *Künstler-Lexikon*, 1924; R.B. Beckett, *Hogarth*, (London, 1949), no. 137, p. 51, ill.; Gabriele Baldini, *L'Opera Completa di Hogarth Pittore* (Milan, 1967), no. 19, p. 89, ill.

Engraved: 1786 by Knight.

William Hogarth, who helped establish a national school of painting, was one of the most original and influential of all British artists. The son of a schoolteacher who was briefly incarcerated, Hogarth had an early exposure to the harsher sides of eighteenth-century life in England and moral anxieties about the meaning of success and failure haunted his art throughout his life. In 1713 he was apprenticed to a silver engraver, and he would remain active as an engraver and printmaker for the remainder of his career.

Many of his paintings had a satirical thrust. He executed series of canvases, usually six or eight, with moralizing narratives, including *The Harlot's Progress* (1731), *The Rake's Progress* (1735), *Marriage à la Mode* (1743) and *Industry and Idleness* (1747). A close friend was the novelist Henry Fielding, whose writings are related to Hogarth's stories. The artist's exposure of mankind's follies and vices has a broad theatricality but also addresses actual moral dilemmas with a realism that resonates over the centuries. Although contemptuous of official artistic instruction, Hogarth was allied with the avant-garde drawing academy in St. Martin's Lane and made his own contribution to aesthetics, *The Analysis of Beauty* (1753).

However, the majority of his activity was devoted to portraiture, in which he excelled. The present portrait was probably executed around 1730 and is characteristic of the type of quick oil sketch with which Hogarth caught a sitter's likeness and expression with charming immediacy (compare, for example, the *Girl with a Tray on her Head*, National Gallery, London). This subject was popularly supposed to represent the future Mrs. Horsley, daughter of the impresario John Rich, who managed the Theatre Royal in Lincoln's Inn Fields. (Hogarth's *Portrait of John Rich and his Family* of 1728 includes an image of his teenage daughter and is owned by the Garrick Club, London). But John Nichols reported that, according to Mrs. Hogarth, the present work was a study of one of the charity girls from St. Martin's parish.

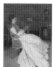

Italian Machiaioli School, latter half of the 19th century
Woman Seated in an Interior
Oil on panel, 15 3/4 x 11 1/2 in. (40 x 29.2 cm)
Private Collection

The depth of the ranks of nineteenth-century painters provides a rich resource for collectors even at the remove of more than 100 years as we enter the twenty-first century. This charming little painting was acquired as simply an anonymous nineteenth-century "Continental" picture, yet it reveals an artist of quality in its broad yet assured handling and strong color sense. A certain attribution is not possible at this time, but the style resembles Sylvestro Lega's. Viewed in profile and seated in a turquoise *fauteuil*, a woman in an ample, high-waisted off-white gown with a short red jacket reads a book or perhaps examines a fan (the object is unclear). At the back is a *secrétaire à pente* with ormolu mounts surmounted with a circular fan, while farther to the right are other furnishings, including an intense blue vase (perhaps a *seau à bouteilles*) on a stand. The painting captures a quiet domestic moment in a comfortably bourgeois setting while providing an interesting juxtaposition in the context of the present show with Giovanni Boldini's elegantly insouciant *Young Woman Reading* (q.v.), who luxuriates in a far more aristocratic setting.

Thomas de Keyser (Amsterdam 1596/97–1667 Amsterdam)
Saint John the Baptist in a Wooded Landscape
Oil on panel, 24 1/2 x 18 1/2 in. (62 x 47 cm)
Private Collection

Provenance: Sale New York (Sotheby's), November 7, 1985, no. 85 [as Adriaen van de Velde]; with Otto Naumann, Ltd., New York [as Thomas de Keyser].

Exhibited: Boston, Museum of Fine Arts, *Prized Possessions*, 1992, np. 77, pl. 73 [as Thomas de Keyser].

This painting sold in 1985 as the work of Adriaen van de Velde, whose figures are usually more thickly painted and display more fully rounded, generalized forms. As Otto Naumann first recognized in reattributing the work, the figure accords better with the rare, small-scale history paintings by the Amsterdam portraitist Hendrick de Keyser. Compare, for example, the treatment of the figures in de Keyser's *Flagellation of Christ*, dated 1637 (Rijksmuseum het Catharijneconvent, Utrecht) and the *Crucifixion on Calvary*, (Pushkin Museum, Moscow); respectively, Ann Jensen Adams, "The Paintings of Thomas de Keyser: A Study of Portraiture in Seventeenth-century Amsterdam," dissertation, Harvard University, 1985, nos. 71 & 72. The treatment of the foliage and landscape may also be compared to the background of de Keyser's later equestrian portraits (e.g.; *Couple on Horseback*, dated 1660, Stiftung Kunsthaus Heylshof, Worms).

St. John the Baptist is regarded as an important link between the Old and New Testaments because he was the last of the prophets in the former and the first of the saints in the latter. Depictions of the saint alone in a woodland setting allude to his ascetic life and retreat to the wilderness, described in the Bible only as "the deserts" (Luke 1:80). Pointing to the lamb, his gesture embodies the phrase "Ecce Agnus Dei," frequently inscribed on his pennant (John I:36): "John looked toward [Jesus] and said 'There is the Lamb of God'." Depictions of the saint in the wilderness are not as plentiful in Dutch art as representations of him baptizing Christ, preaching, or being beheaded. However, the subject had been treated earlier by Rembrandt's influential teacher, Pieter Lastman, in a painting dated 1616 in the Mead Art Gallery, Amherst. De Keyser made at least one copy of Lastman's work (see Institut Néerlandais, Paris, no. 6781). The dark brown foliage of the present picture was probably once greener in hue; greens were notoriously fugitive pigments in the seventeenth century. An interesting detail in this painting is the pentimento around the saint's right foot; the artist adjusted its position as he sought a more gracefully relaxed pose.

Judith Leyster (Haarlem 1609–1660 Heemstede)
Head of a Young Girl
Oil on panel, 7 3/4 in. (20 cm) diameter
Collection Mrs. Thomas Mellon Evans

Provenance: P. de Boer Gallery, Amsterdam, 1968; acquired from Newhouse Gallery, New York.

Judith Leyster was the daughter of a Haarlem brewer, who took his surname from the name of the brewery – "Ley-ster" (lodestar). Although only eighteen at the time, she was already mentioned as an artist in 1627 by the chronicler of Haarlem, Samuel Ampzing. In all likelihood she was a pupil of the leading portraitist in town, Frans Hals, whose brilliant painterly technique influenced her style. She was a witness at the baptism of one of Hals's children and seems to have been close to the family. Frans's brother, Dirk Hals, also evidently influenced her genre paintings with small figures. Leyster became a master in the Haarlem guild in 1633, the first woman admitted. In October 1635 she went before the guild to demand compensation from the mother of a student who had left her studio to join Frans Hals's. In 1636 she married the painter Jan Miense Molenaer. The couple moved to Amsterdam where they lived until 1648 before moving to Heemstede, where she died in 1660. One of the most accomplished woman painters of the seventeenth century, Judith Leyster was primarily a genre painter, favoring images of children, but also painted portraits and, rarely, still lifes.

The present work is not signed nor is it catalogued in the monograph on the artist (Frima Fox Hofrichter, *Judith Leyster, A Woman Painter in Holland's Golden Age*, Doornspijk, 1989). However, it bears many of the stylistic qualities associated with the artist – the bold and swift brushwork, the strong and colorful palette, and the charming conception of the young subject in profile, with her ruddy cheek and loose lock of hair. Even details like the use of the butt-end of the brush to create highlights in her coiffure recall Leyster's manner. This type of *tronij* or head study was inspired by works executed by Frans Hals in the 1620s.

Elmer Livingston MacRae (New York, NY 1875–1953 Greenwich, CT)
Schooner in the Ice, 1900
Signed l.r. *EL MAC RAE /1900*
Oil on canvas, 25 x 30 in. (63.5 x 76.2 cm)
Collection Mrs. Hugh B. Vanderbilt

Exhibited: Greenwich, CT.: Bruce Museum, *On Home Ground: Elmer Livingston MacRae at the Holley House*, 1990.

Literature: Susan G. Larkin, "The Cos Cob Clapboard School" in *Connecticut and American Impressionism*, exh. cat. (Storrs: The University of Connecticut, 1980), pp. 82-99, 167; William H. Gerdts, *American Impressionism* (New York: Abbeville Press, 1984); Susan G. Larkin, *On Home Ground: Elmer Livingston MacRae at the Holley House*, exh. cat. (Greenwich, CT.: Bruce Museum, 1990), ill. pl. 5; Susan G. Larkin, *The Cos Cob Art Colony*, exh. cat. (New York and New Haven: National Academy of Design and Yale University Press, 2001), p. 74, cat. no. 40.

Schooner in the Ice combines many of the fundamental elements of a characteristic Elmer MacRae oil painting: effective composition, subtly harmonious colors, accurate details, and Impressionist-inspired subject matter. Perhaps most importantly, it is a view from the Holley House, which served as MacRae's inspiration for more than half a century. MacRae devoted most of his artistic career to portraying what scholar Susan Larkin has so aptly termed his "portraits of a place," compositions that faithfully reproduced, with loving attention, the familiar scenes within the immediate vicinity of his home.

Born in New York City, MacRae attended Fordham

College for one year before enrolling in the Art Students League in 1895. There he studied under J. Carroll Beckwith, Robert Blum, Siddons Mowbray, and John Henry Twachtman, the latter of whom was to have a lasting influence on his art. About 1890 Twachtman had founded a small art colony in Cos Cob, Connecticut, where he taught summer painting classes. In 1896 MacRae became a pupil there, joining fellow classmates from the Art Students League as well as newcomers like Japanese artist Genjiro Yeto, with whom he became good friends. Loosely based on the European studios and sketching parties to which Twachtman himself had been introduced as a student, the Cos Cob colony provided a friendly, supportive atmosphere in which students mingled with professional artists, including Childe Hassam (q.v.), J. Alden Weir, Theodore Robinson, Leonard Ochtman, and sculptor Edward Clark Potter. Out of the confines of the city, artists and teachers sketched the countryside in the open air, sharing ideas, techniques, and encouragement.

The Holley family boardinghouse, located on Cos Cob's Lower Landing, served as a central meeting place for the artists in the colony. It provided inexpensive accommodations for art students as well as writers, actors, journalists, and musicians, creating a dynamic community in which to paint and exchange ideas. From the start MacRae found an inexhaustible number of subjects to keep him occupied. The Holley House and its residents, the countryside along Long Island Sound, and Cos Cob's shipyard, village and people became the heart of his work. He found even more to study after marrying the Holleys' daughter, Constant, in 1900; thereafter he included portraits of his wife and their twin daughters, born in 1904, in his repertoire.

After his marriage, MacRae settled permanently at the Holley House. He was actively involved in arts organizations, helping to found the American Pastel Society and to conceive and organize the Armory Show of 1913, which greatly increased American knowledge of modern European art. Though contemporary critics often focused on his work in pastel, MacRae's oil paintings are also well-conceived compositions, often revealing Twachtman's influence. *Schooner in the Ice* remains faithful to some of Twachtman's favorite subject matter; like his professor, MacRae loved to paint the snow, reveling in the reflection of light on ice and winter water. Yet the present piece deviates from the stylistic mode of Twachtman, who often abandoned detailed renderings in favor of more abstract images. Here MacRae has faithfully recorded all aspects of the landscape – the masts and rigging of the old workboat in the foreground as well as the steel and concrete of the modern railway bridge beyond. Despite these extremes in subject matter, he manages to convey, through his careful details, the beauty in all that surrounds him.

Edouard Manet (Paris 1832–1883 Paris)
*Portrait de Manet par lui-même, en buste
(Self-Portrait, bust length),* c.1878
Oil on canvas, 33 5/8 x 28 in. (85.3 x 71 cm)
Private Collection

Provenance: Mme. Manet, Paris; acquired from her by Paechter, Berlin, December 1899; Auguste Pellerin, Paris, c.1910; Marquise de Ganay, Paris; Jakob Goldschmidt, Berlin, c.1931; Sale London (Sotheby's), October 15, 1958, no. 1; John L. and Frances Loeb, New York; Sale John L. and Frances Loeb, New York (Christie's), May 12, 1997, no. 107, ill.

Exhibited (selected): Philadelphia Museum of Art, *Edouard Manet,* 1966, p. 148, no. 144, ill.; Washington, D.C., National Gallery of Art, *Manet and Modern Paris, 1983,* no. 1, ill.; Paris, Grand Palais, and New York, Metropolitan Museum of Art, *Manet, 1832–1883,* 1983, no.164.

Literature: (selected, for full bibliography, see Loeb sale catalogue, 1997): E. Moreau-Nelaton, *Catalogue Manuscrit de l'oeuvre de Manet* (Paris, n.d.), no. 236; T. Duret, *Histoire d'Edouard Manet et son oeuvre* (Paris, 1902), p. 256, no. 245; J. Meier-Graefe, *Edouard Manet* (Munich, 1912), p. 253, fig. 149; E. Moreau-Nelaton, *Manet raconté par lui-même* (Paris, 1926), vol. II, pp. 50–51, fig. 235; J. Richardson, *Edouard Manet, Paintings and Drawings* (London, 1958), p. 129, number 71, ill.; J. Rewald, *History of Impressionism* (New York, 1961), p. 404, ill.; D. Rouart and S. Orienti, *Tout l'oeuvre peint de Manet* (Paris, 1970), p. 110, no. 274, pl. XLVIII; P. Gay, *Art and Act* (New York, 1976), p. 35, fig. 17; *The Frances and John J. Loeb Collection* (London, 1982), no. 13, ill.; J. Richardson, *Manet* (London, 1982), p. 26, fig. 10; F. Cachin, *Manet* (Paris, 1991), p. 25, ill.; B.A. Brombert, *Edouard Manet: Rebel in a Frock Coat* (Boston, 1996), ill.on cover.

The critical figure at the inception of Impressionism, Edouard Manet challenged academic and stylistic conventions to create a new type of painting based on modern life. With controversial works like his famous *Déjeuner sur l'Herbe* (Musée du Louvre, Paris), which was rejected by the jury of the Salon in 1863 but then defiantly exhibited by the artist in the first *Salon des Refusés,* Manet stepped to the fore in the rebellion that changed the course of art. Yet unlike an artist like Courbet, who styled himself a representative of the common man leading a revolution of Realism, Manet was an unlikely revolutionary – a born gentleman from a distinguished upper-class Parisian family. On his father's side he descended from respected Parisian magistrates and wealthy landowners and local officials at Genoevilliers, while his mother's family boasted no less accomplished diplomats and military leaders. He enjoyed inherited means, favored fashionable dress and society, and by all accounts displayed impeccable manners.

To his friend and champion, the novelist Émile Zola, he confessed that he "adored society and discovered secret pleasures in the perfumed and brilliant delights of evening parties." In his own literary portrait of the artist composed in 1867, Zola described Manet as "of average height, more short than tall. His hair and beard are pale chestnut; his eyes, which are narrow and deep-set are full of life and youthful fire; his mouth is characteristic, thin and mobile and slightly mocking at the corners. The whole of his good-looking, irregular and intelligent features proclaim a character, both subtle and courageous, and a disdain for stupidity and banality. And if we leave his face for his person, we find in Edouard Manet a man of extreme amiability and exquisite politeness, with a distinguished manner and sympathet-

ic appearance" (quoted in T.A. Gronberg, *Manet: A Retrospective* [New York, 1988], p. 64). Although he was an audacious painter, Manet presented to the world the refinements of a dandy and *boulevardier*. Indeed, the journalist Firmin Javel observed that while Manet might emulate the painting style of Velasquez, he "dressed, ate and lived like Monsieur Bouguereau" (q.v.), the quintessential academic painter.

It is fitting therefore that in the present painting Manet depicts himself in time-honored fashion with the tools of the artist's trade – the palette and brushes – but dressed elegantly in a handsomely tailored tan frock coat, fashionable hat and dark cravat secured by a bright stickpin. This is highly unlikely attire for the messy work of the studio, even for an avowed dandy and *flaneur*, but accords well with contemporary accounts of Manet's public demeanor; as his friend George Moore described him: "although by birth and by art essentially a Parisian, there was something in his appearance and manner of speaking that suggested an Englishman. Perhaps it was his dress, his clean-cut clothes and figure" (quoted in exh. cat. Philadelphia Museum of Art, 1966, p. 159). Clearly Manet is here presenting a portrait of his public persona as well as a likeness of himself.

As so many artists had done before and after him, he must have painted his self-portrait while looking in a mirror, since he holds the brush in his left hand but was right-handed. The wonderful painterly freedom and assurance with which the picture is executed is a virtuoso visual demonstration as well as a reaffirmation of the stylistics of "quick painting" that he championed in those years. While he sometimes included himself in his genre scenes of Parisian society, this is one of only two pure self-portraits that Manet ever painted (the second is a small full-length image, also painted about 1878, and now preserved in the Bridgestone Museum of Art, Tokyo). It masterfully encapsulates his self-image, public and private, while trumpeting to the world his artistic intellect and creative prowess.

Willard Leroy Metcalf (Lowell, MA 1858-1925 New York, NY)
The Violets, 1903
Signed and dated u.l. *Willard L. Metcalf 1903*
Oil on canvas, 30 x 26 in. (76.2 x 66 cm)
Collection Richard and Mary Radcliffe

Provenance: Private Collection Jeanne Norsworthy; thence by descent.

Exhibited: *Ten American Painters*, Durand-Ruel Galleries, New York, 1903, no.10.

Literature: Elizabeth de Veer and Richard J. Boyle, *Sunlight and Shadow: The Life and Art of Willard L. Metcalf* (New York: Abbeville Press, 1987), pp. 66-67 illus., fig. 69; Patricia Jobe Pierce, *The Ten* (Concord, N.H.: Rumford Press, 1976), pp. 93-99, William H. Gerdts, *American Impressionism*, exh. cat. (Seattle: Henry Gallery Association, 1980).

Though recognized today primarily for his Impressionist New England landscapes, Willard Leroy Metcalf did not fully adopt that style until relatively late in his career. Just after the present work was completed he experienced what he called his "Renaissance," when he began to lighten his palette and loosen his brushstrokes. Before that time, he had worked mainly in portraiture and illustration, his canvases characterized by clearly defined color and deliberate brushwork.

At seventeen, Metcalf became a student of George Loring Brown, an academic artist trained in Paris. Brown instilled in Metcalf a profound respect and understanding for painting the truth in every scene. Under his tutelage Metcalf learned to draw natural formations realistically and to paint figures with precision. These lessons developed into an appreciation for academically accurate figure pieces, an aim that is particularly evident in *The Violets*. The painting's precise execution, hard lines, and absence of artificiality combine to produce a direct style, which by this time had become Metcalf's signature. Nevertheless, the portrait radiates a quiet elegance and warmth, proving his ability to capture emotion with equal skill.

The subject of the portrait is Marguerite Beaufort Hailé, who was then a popular model among New York artists. In 1892 she had posed for Siddons Mowbray's *Youth and Crabbed Age*, and by the age of twenty-one had become the principal model for Metcalf's murals in the Appellate Court House on Madison Square. From then on she posed frequently for Metcalf, and the two were married shortly after this portrait was completed. The canvas displays Marguerite against a bright orange background that contrasts strikingly with the sober colors of her plumed hat and elegant dress. This is most likely the outfit she had worn in January 1903 to the fashionable opening of the Havana Tobacco Company Store, for which Metcalf had painted a decorative frieze of Cuban city and harbor scenes (see de Veer and Boyle, p. 67). Metcalf sent *The Violets* to an exhibition of the Ten in April 1903 along with two other paintings – *Havana Cathedral* and *Battery Park Spring*.

Gabriel Metsu (Leiden 1629–1667 Amsterdam)
Woman Selling Fish
Oil on canvas, 12 x 10 3/4 in. (30.5 x 27.4 cm)
Private Collection

Provenance: Private Collection, France, until 1990; with Agnew's, London.

Gabriel Metsu was the son of the Flemish painter Jacques Metsue and was born in Leiden in 1629 shortly after his father's death. Nothing is known of his youth or artistic training, but Houbraken assumed he had been a pupil of Gerard Dou. While Metsu adopted themes and compositional devices from Dou, such as the depiction of figures in "niches" or windows, he developed a colorful and gracefully fluent style that is readily distinguished from the minute touch of the true Leiden *fijnschilders*. In March of 1648 he became a founding member of the Leiden Guild. By May of 1657, like so many ambitious artists of the period, he had moved to the bustling city of Amsterdam and was reported living on the Prinsengracht. The following year he married Isabella de Wolff from Enkhuizen, daughter of the woman painter, Maria de Grebber of Haarlem. He was only thirty-nine when he died in 1667.

Metsu painted a few history paintings, most of which date from his early period before c.1655, but the majority of his paintings are genre scenes. He also painted a handful of portraits, still lifes and game bird pieces. While Metsu is perhaps best remembered for his images of upper class figures in elegant interiors, he executed at least as many images of domestic subjects, tavern dwellers and street vendors. Metsu repeatedly painted poultry, vegetable and fish vendors like the present one. He probably observed street vendors on a daily basis in Amsterdam since his home on the Prinsengracht was just north of the town's vegetable market, which seems to be depicted in his well known painting of a marketplace in the Louvre, Paris (see Linda Stone-Ferrier, in *The Art Bulletin*, vol. 61 [September 1989], pp. 428-452). The presumption that the pretty lady cleaning fish with a knife in the present work is a professional fishmonger rather than a housewife or servant is supported by the brass scale that hangs from a hook on the brick wall to the right. The painting bears some relationship in theme and design to a work by Metsu in the Marquis of Bute's collection, which also offers a three-quarter-length view of a woman cleaning fish at a table before an arched doorway and a brick wall (see F. Robinson, *Gabriel Metsu, 1629–1667. A Study of his Place in Dutch Genre Painting of the Golden Age*, New York, 1974, fig. 51). Other images of women fishmongers by Metsu are in the Duke of Sutherland's Collection, St. Boswell's, the Narodni Gallery, Prague, the Rijksmuseum, Amsterdam, and the Wallace Collection, London, (respectively, Robinson 1974, figs. 55, 53, 87 & 88). The subject of fish vendors and their stalls had first been popularized by sixteenth-century Flemish artists like Joachim Beuckelaer (see his *Fish Stall* in the Musuem in Ghent) and later remained popular with Flemish Baroque still painters like Frans Snyders, whose life-size fish stands often include a superabundance of sea life. A more intimately conceived tradition of depicting fish vendors was developed in the Northern Netherlands by painters like Hendrick Sorgh, Nicholas Maes and Jan Steen, probably prior to Metsu's adoption of these subjects. It is a testament to the Dutchman's celebration of the beauty of the quotidian aspects of daily life that the theme should have enjoyed such popularity and been treated with such loving attention.

Frans van Mieris (Leiden 1635–1681 Leiden)
The Death of Lucretia, 1679
Signed l.r. *Mieris*
Oil on panel (arched top),
15 x 10 5/8 in. (38 x 17 cm)
Private Collection

Provenance: Sale, Count of Fraula, Brussels, 21 July 1738, no. 245 (700 francs); Sale, Bicker van Zwieten, The Hague, 12 April 1741, no. 52; Collection Willem Lormier, The Hague, 1752, and his sale, The Hague, 4 July 1763, no. 166 (f. 625 to van Heteren) Collection A.L. van Heteren, The Hague, and by descent to A.L. van Heteren; in 1809 the entire Gevers collection was purchased by Cornelis Apostool for the Royal Museum (now Rijksmuseum), Amsterdam; Sale, Royal Museum, Amsterdam, 4 August 1828, no. 88 (f290 to Roos); Sale, Jhr. Steengracht van Duivenvoorde from The Hague, Paris, Galerie G. Petit, cat. By F. Lugt; Sale, Paris, Ader, Picard and Tajan, 8 December 1977, no. 25; illus. Gallery Pieter de Boer, Amsterdam, Private Collection, Sweden; Saul Steinberg, New York, USA, purchased from Johnny van Haeften.

Literature: C. Hofstede de Groot, *Catalogue raisonné ...*, vol. 10 (1928), no. 29; O Naumann, *Frans van Mieris the Elder* (Doornspijk, 1981), pp. 120–122, no. 116, pl. 116, 116a; Meredith M. Hale, catalogue entry on Frans van Mieris's *The Death of Lucretia*, for Johnny van Haeften, London, n.d.

A pupil of Gerard Dou, Frans van Mieris was the most distinguished member of the Leiden *fijnschilders*, most of whom were active in the university town of Leiden and who painted in an extremely fine manner with minute detail and high polish. Van Mieris painted genre scenes, portraits and a few Biblical themes, but only two themes from antiquity, *Gyges and the Wife of Candaules* of around 1670 (Staatliches Museum, Schwerin), and the present work of 1679. Both are late works. In his late manner, van Mieris's touch became more enameled and his palette darker and more saturated, with almost iridescent highlights. The subject of the painting is derived from Livy's *History of Rome*, which recounts the story of the virtuous Lucretia. Raped by Tarquinius, she reported the crime to her husband and then took her own life, saying "Never shall Lucretia provide a precedent for unchaste women to escape what they deserve." The public outrage against the Tarquins that ensued overthrew the monarchy and established Rome as a republic. The story of the death of Lucretia, with its message of the ultimate triumph of virtue and the noble origins of a republican form of government, was very popular in the United Netherlands. Plays based upon the theme were performed in Amsterdam, including D.P. Pers's *Lucretia, ofte het beeld der eerbaerheydt ...* (1624), and Neuye's *De gewroke Lucretia, of Romen in vryheit* (1669).

Other artists, notably Rembrandt, treated the theme, but rarely in such an intimate format. Van Mieris's treatment is theatrical, featuring the old woman wringing her hands in horror as she discovers the swooning suicide. However, notwithstanding the suggestion of classical drapery in the old woman's costume and details such as the classical statue in the niche in the distance, the setting is similar to one of the artist's genre scenes: the upholstered chair, the covered bed at the back, the rich still life of oriental carpet, velvet and fur-lined wrap and lute to the left, not to mention the barking lapdog. The violence of the scene is minimized; the inconspicuous suicide weapon looks like a bread knife and Lucretia's wound, despite her ample and erotic décolleté, is unseen. As Meredith Hale observed in cataloguing this picture, the bourgeois setting of the present scene and its exaggerated anguish conform in the literary theory of the seventeenth century more to the realm of Comedy than to that of Tragedy. In this regard, the painting aligns itself with the many other scenes by van Mieris of brothels and taverns with broadly caricatured procuresses and mugging drinkers.

Claude Monet (Le Havre 1840–1926 Giverny)
The Cliffs near Fécamps, 1881
Signed and dated l.r. *Monet 81*
Oil on canvas, 23 3/4 x 32 in. (60 x 81 cm)

Private Collection
Provenance: Bought from Monet by the dealer Durand Ruel of Paris, in May 1881; Erwin Davis, New York; with Durand Ruel, Paris, 1893.

Exhibited: Paris, 251 Rue Saint-Honoré, *7th Exposition des artistes indépendents*, 1882, no. 76; New York, Durand Ruel Gallery, *Claude Monet*, 1895, no. 17.

Literature: Daniel Wildenstein, *Claude Monet. Biographie et catalogue raisonné*, 3 vols., vol. 1 (Paris, 1974), pp. 117, 392, no. 649, ill.

A native of Le Havre, Claude Monet became the most distinguished and devoted of all the great Impressionist landscapists. While still working as a caricaturist in his hometown, Monet encountered the painter Eugene Boudin, who was then a specialist in seascapes and coastal views of Normandy. More than a mere ship's portraitist, Boudin made the recording of the specifics of the light and weather his primary subject, almost an obsession, dating his pastels and paintings virtually to the hour. Monet regarded Boudin as his teacher and credited him with having first encouraged him to paint landscapes out-of-doors, *en plein air*. The practice became the essence of Impressionism, a diverse style devoted in its purist form to images of the contemporary world and its landscape, depicted spontaneously with divided light and color. Yet, as these important artistic milestones passed, the dramatic coastline of Monet's youth would remain a vivid memory and source of inspiration.

The present painting is a mature work by Monet, when he had established himself as a leading exponent of Impressionism and made his revolutionary style a viable manner in Paris. However, by the early 1880s when this painting was executed, many of Monet's colleagues, including and most notably Renoir, Pissarro and Cézanne, had abandoned the classic Impressionist style for other manners, often involving strategies to counteract the atmospheric style's inevitable dissolution of form. However, Monet would remain wedded to the tenets of Impressionism throughout his career, constantly discovering new variations and creative idioms.

The present work was probably painted from the top of the seaside cliffs near the village of Fécamps on the Normandy coast, in March or April of 1881. This visit was in many ways a return to roots for Monet, since he had already painted in Fécamps and Cap Fagnet thirteen years earlier, in 1868. More fundamentally, he had considered in artistic terms his native Normandy coastline's dramatic topography for years. As we have suggested, Monet was by this point an artist returning to the sites and sources of inspiration of his youth, looking for resonant themes and designs. Indeed, as France's emergent national landscapist, he was looking for landscapes that would resound visually with national pride. He had already renewed his interested in this dramatic scenery when he visited the cliffs of nearby *Les Petites Dalles* the previous year in September 1880. Now he returned to the *falaises* of Fécamps in the early spring of 1881 and depicted the view from the precipice as well as the base of its cliffs, looking south as well as north toward Grainval.

Monet painted at least four paintings from approximately the same view and direction as the present work (see Wildenstein, 1974, nos. 647-650). Closely allied in composition, they are extraordinarily daring for their variations on a dramatic viewpoint, juxtaposing near and far in an imbalanced design. The latter concentrates on a foreground dominated by a darker and daringly marginalized, blunt cliff on the left, silhouetted against the lighter expanse of a surprisingly freely painted, frothy ocean below. The compositional device is traditionally known as a *repoussoir*, but it is applied here in a boldly daring fashion, especially by the standards of the time, indeed one that anticipates by its freedoms the art of the modern and contemporary era that dominates the rest of the owners' collection. Almost ten years after the present work was executed, Monet would codify the practice of systematically examining a landscape site in serialized views – a practice that revolutionized modern art, with its emphasis on variations and permutations of themes.

Berthe Morisot (Bourges 1841–1895 Paris)
Young Woman and Child, 1894
Signed l.l. *Berthe Morisot*
Pastel on paper, 29 x 24 in. (73.7 x 61 cm)
Private Collection

Exhibited: Paris, Galerie Durand Ruel, *Grande Exposition des Oeuvre de Berthe Morisot*, 1896, no. 182; Paris, Galerie Bernheim Jeune, 1919, no. 84.

Literature: M.-L. Bataille and G. Wildenstein, *Berthe Morisot. Catalogue des peintures, pastels et aquarelles* (Paris, 1961), cat. no. 605, fig. 592.

Born in Bourges, Berthe Morisot was the daughter of the Prefect of Cher, a cultivated gentleman. Together with her two sisters, she took drawing lessons with a local master before entering the studio of Camille Corot, with whom she studied from 1862 to 1868 and who influenced her early landscapes. She soon met Henri Fantin-Latour and other artists, including Edouard Manet, for whom she posed and who had a lasting influence on her art. Exhibiting at the Salon as early as 1865, Morisot began to paint *en plein air* in 1873, developing her own distinctive brand of Impressionism characterized by a daringly free brush and feathery strokes. In addition to landscapes, she produced portraits, figure paintings and delicate still lifes. Especially distinctive are her pastels.

This pastel was executed in the penultimate year of the artist's life in her home on the rue Weber in Paris. It depicts a favorite model, Jeanne-Marie, and a little girl named Marcelle, whom Morisot had met in the street. When Morisot first encountered the child, whom she affectionately called "petite Marcelle," the young girl is purported to have introduced herself matter-of-factly with the statement, "Je suis Marcelle, petite fille" (see Bataille and Wildenstein, p. 21). The pastel was one of 300 works by the artist exhibited a year after her death in a retrospective at the Galerie Durand Ruel with a catalogue that featured a preface by the artist's friend, the poet Stéphane Mallarmé.

Rembrandt Peale (Bucks County, PA 1778–1860 Philadelphia, PA)
Portrait of George Washington, c.1840s
Oil on canvas, Oval, 38 1/2 x 30 1/2 in.
(97.8 x 77.5 cm)
Collection Mr. and Mrs. Robert A. Simms

Literature: Carol Eaton Hevner, *Rembrandt Peale, 1778–1860: A Life in the Arts*, exh. cat. (Philadelphia: Historical Society of Pennsylvania, 1985), pp. 88–89; John Wilmerding, "Rembrandt Peale's *Rubens Peale* with a Geranium" in *American Views: Essays on American Art* (Princeton, NJ: Princeton University Press, 1991), pp. 143–162; William T. Oedel, "The Rewards of Virtue: Rembrandt Peale and Social Reform" in *The Peale Family: Creation of a Legacy 1770–1870*, ed. Lillian B. Miller (New York: Abbeville Press, 1996), pp. 151–167.

Born on George Washington's birthday, Rembrandt Peale was the son and pupil of Federal era painter Charles Willson Peale (1741–1827). Following in his father's footsteps, Rembrandt began to draw as a youngster, and by the age of thirteen had painted his first *Self-portrait* (1791; private collection). His lifetime was marked by diverse artistic endeavors; originally he worked as a professional portrait painter, and later tried his hand at the museum profession. In 1802 and 1803 he studied in London with Benjamin West, and traveled to Paris in 1808 and 1809–1810 to work with François Gerard and Jacques Louis David. Influenced by West and David, he even attempted historical scenes, exhibiting his *Court of Death* (1820; Detroit Institute of Arts) with much success. However, Peale ultimately returned to portrait painting, establishing himself as an accomplished artist with heroic likenesses of Thomas Jefferson and, most notably, George Washington.

Unlike Ralph Earl (q.v.), who largely painted outside the center of American political life, Rembrandt Peale grew up in Philadelphia in the midst of the new nation's most prominent scientists, artists and politicians. At the age of seventeen he won a commission to paint a life portrait of George Washington (1795; Philadelphia, PA, Historical Society), and it was to this experience that he returned almost thirty years later, hoping to reestablish his artistic reputation. In 1823 Peale announced his intention to create a "standard likeness" of the deceased president. One of only five artists then alive to have painted Washington from life, Peale believed that combining the most excellent features of these original portraits would produce a likeness that would exceed all others in its authenticity. Working from his own 1795 image and others he admired, including his father's portrait of the same year and the famous 1785 bust by French sculptor Jean-Antoin Houdon, Peale strove to create a definitive likeness, even going so far as to solicit testimonials of authentication from Washington's former associates.

This quest resulted in Peale's *George Washington Patriae Pater* (c.1824; Collection of the United States Senate, Washington, D.C.). Dubbed the "porthole" portrait because of its oval trompe l'oeil frame, the painting depicted a bust of Washington surrounded by a large masonry monument displaying the head of Zeus and a plaque inscribed with the phrase "Patriae Pater" (father of the country). This first composite inspired a lifetime quest to replicate the

President's image, and by his death in 1860 Peale had made almost eighty copies varying on the theme of his original.

Peale's strong sense of civic responsibility led him to create work laden with ethical implications: he used his Washington portraits, which had widespread public appeal, to deliver a message of virtue and morality to a new nation. Drawing on his knowledge of physiognomics (a predecessor of phrenology), he believed that a close inspection of physical attributes could reveal traits of character. Washington's carefully modeled, idealized features – the square face and jaw, broad forehead, and wide aqiline nose – are meant to convey his intelligence, dignity, and morality, all traits that Peale believed essential to the foundation of the new nation.

The present work is a particularly fine "porthole" portrait. Larger than many of Peale's copies, it is unique in its depiction of the President in civilian dress, rather than in his usual military attire. Washington is set against a plain, bright background that emphasizes the rich textural detail of his facial features. Dignified in old age, he indeed appears as the embodiment of national paternity. The painting itself is a tribute to Peale's linear clarity and fluid style, as well as his attention to glazing and finishing techniques, with which he frequently experimented.

Jean-Baptiste Pillement (Lyon 1728–1808 Lyon)
View of Tagus, Portugal, with Ships and Boats in a Rough Sea and *A Mountainous Landscape with Two Footbridges and Travelers* (a pair), 1790
Both dated l.l. *1790*
Oil on canvas, 24 x 33 3/4 in.
(61 x 85.7 cm)
Collection Suzanne and Norman Hascoe

Provenance: Sale New York (Christie's), 1992 or later.

Born in Lyon, J. B. Pillement began his career as a painter of charmingly inventive *chinoiserie* decorations, and a delicate instinct to ornament distinguished his art ever after. He traveled to Paris, Madrid and Lisbon before visiting England, where he took up landscape painting in the 1750s. A peripatetic artist, he moved back to Paris in 1761 and later traveled to Turin, Rome, Milan, Vienna and Warsaw, where he became court painter to King Stanislaus III Augustus. From 1780 to 1786 he resided in Portugal, where he founded a drawing academy in Oporto. After a period in Madrid, he returned at the end of his career to his birthplace.

The tower on the left of the Tagus appears in several other paintings by the artist and attests to his years in Portugal; compare, for example, the painting dated 1785 that appeared in the sale, London (Christie's), December 11, 1992, lot 38, and the picture dated 1782 that appeared in exh. cat. Atlanta, *The Rococo Age; French Masterpieces of the Eighteenth Century*, 1983, no. 162. Pillement developed an elegantly refined landscape style that was more intimate and delicately playful than the works of Claude Joseph Vernet, but often treated similar marine subjects, coastal views and the occasional shipwreck. His landscapes, with which he often paired seascapes, favor decorative motifs such as picturesque footbridges over ravines with fantastic rock formations. His genial palette runs by turns to heightened keys of

tawny yellows or pearly grays and slate blues, while his touch ranged from enameled surfaces to thickly daubed highlights.

Camille Pissarro (St. Thomas 1830–1903 Paris)
Landscape in the Vicinity of Conflans Sainte-Honorine, 1874
Signed l.l. *C Pissarro*
Oil on canvas, 17 3/4 x 22 in. (45 x 56 cm)
Private Collection

Provenance: Probably Gallerie Georges Petit, Paris, from whose owner it was acquired in the 1920s, thence by descent to Bertil Steen, Oslo; with Dickenson Roundell Inc., New York.

Exhibited: Henie-Onstad Art Center, Oslo, on loan 1995–1998.

Literature: To be included in the new Pissarro *Catalogue Raisonné* currently being prepared by the Wildenstein Institute, ref. no. 95.07.12.4344.

Camille Pissarro moved his family in 1866 to Pontoise, a small town eighteen miles northeast of Paris. Situated on a series of hills overlooking the Oise River, Pontoise was distant enough from Paris to retain its own rural identity but also accessible to the capital by the railroad that had arrived there just three years before. Working in and around the town through 1883, Pissarro created a portrait of Pontoise and its environs that is unprecedented in nineteenth-century landscape painting in its sustained comprehensiveness. He painted its lovely rolling hills, slender poplars and redolent fields, as seen in the present work, as well as signs of Pontoise's modernization (factory chimneys and the street lights and fashionably dressed figures that suddenly appeared on the village streets). However, Pissarro eschewed the images of recreation and leisure that captured the fancy of his fellow Impressionists, Monet and Renoir, favoring instead agrarian landscapes.

The present work was created in 1874 during the two-year period (1872–1874) that is generally regarded as his classic Pontoise years, when Pissarro painted some of the finest pure landscapes of the first Impressionist period. Whereas his earliest paintings of Pontoise had revealed his debt to Corot, Courbet and Daubigny, he now found his own pictorial voice, featuring a lightened palette, an unerring sense of *plein-air* tonal values applied with a broad and confident brush, and a sure sense of the geometric substructure of his landscape designs. We note in the present work how masterfully the vertical accents of the trees establish a rhythm and portion out the land without compromising its expansive sweep. Writing of the artist's work in this period, Richard Brettell (*Pissarro and Pontoise*, 1990, p. 160) has noted the "unrivaled spaciousness" of the paintings of this two-year period "that mark, in many ways, the apex of Pissarro's career as a landscape painter." After 1880, figures often became more prominent in his compositions and pure landscapes are far less common.

The site here is Conflans Sainte-Honorine, which is south of Pontoise and close to Eragny-sur-L'Oise. On the painting's stretcher there is a pencil inscription in French: *Paysage à Eragny (Oise) [Landscape at Eragny (Oise)]*.

Edward Henry Potthast (Cincinnati, OH 1857–1927 New York, NY)
Moonlight
Signed l.r. *E. Potthast*
Oil on composition board, 16 x 20 in. (40.6 x 50.8 cm)
Collection Mrs. Hugh B. Vanderbilt

Literature: Arlene Jacobwitz, *Edward Henry Potthast 1857–1927*, (New York, 1969).

Potthast's formal artistic training began at an early age with classes at Cincinnati's McMicken School of Design. There he laid a foundation of creative ability that earned him an apprenticeship in a lithography company at the age of sixteen. In 1882 he took the first of two trips to Europe, where he studied in Antwerp with Charles Veriat and later in Munich under Nicolas Gysis, Ludwig von Loefftz, and possibly Carl Marr. Early works (see *Dutch Interior*, 1890, Cincinnati Art Museum) are heavily influenced by the dark tonalities of the Munich School. Yet it was a second trip to Europe, this time to France in 1887, which marked the turning point in Potthast's artistic style. He became interested in the French Impressionists and began producing colorful studies that showed the influences of Robert Vonnoh and Irish Impressionist Roderic O'Conor. Canvases like *A Brittany Girl*, 1889 (Smithsonian American Art Museum) earned him the recognition of critics at exhibitions in both Paris and Munich.

Back in America, Potthast settled down to serious work on landscapes, and about 1900 began seeking new sketching material with summer trips along the New England coast. In locations from Long Island to Maine, he painted the beach scenes that were to become his principal subject matter. Many compositions focused on New York's middle class at the turn of the century; they portray children frolicking, families picnicking, and people sitting under brightly-colored umbrellas. At other times, as in the present work, the artist's seascapes were devoid of human presence, focusing instead on relating to canvas the beauty and serenity of the ocean scenery.

That Potthast was a master of modified Impressionism is quite evident in *Moonlight*. The brushwork fluctuates between the broken Impressionist strokes of the waves in the foreground and the broad linear blues that define the sky and the calmer sea beyond the shore. However, the work's chief strength is perhaps its exquisite color, which enhances the effects of moonlight on the sea. A delicate light pervades the scene, the pale yellow of the moonbeam refracted and intensified in the crests of the breaking waves. These splashes of brilliance complement the rich darkness of the rocks and undersides of the waves; like other artists of his time Potthast did not use black, but instead strengthened his deeper shadows with blues and purples. The gentle play between these contrasts in color mimics the tug of the waves lapping at the land, tying together the elements of the composition.

Pieter Gerritsz van Roestraten (Haarlem 1629/30–1700 London)
Trompe-l'oeil Still Life with Precious Objects
Signed l.r. *P. Roestratten*
Oil on canvas, 37 1/2 x 43 1/4 in. (95.2 x 110 cm)
Private Collection

Provenance: Mr. and Mrs. W. Reich; Sale New York (Christie's), June 15, 1977, no. 87; with dealer Waterman, Amsterdam; Sale New York (Sotheby's), June 4, 1987, no. 77; with dealer Heidi Hubner, Würzburg; Private Collection, Germany.

Literature: R. Baljöhr et al., *Das Kabinett des Sammlers. Gemälde vom XV. bis XVII. Jahrhundert* (1993), pp. 214–16, no. 86, ill. (entry by Susanne Rütten); A. Chong and Wouter Kloek, in *Still Life Paintings from the Netherlands 1550–1720*, Amsterdam, Rijksmuseum, 1999, pp. 270–71, fig. 72a.

Roestraten registered in the Haarlem St Luke's Guild as a portraitist in 1646, the same year he entered the workshop of the famous portraitist Frans Hals, whose daughter he married in 1654. Between 1663 and 1665, the couple moved to England, where according to B. Buckeridge (see R. de Piles, *The Art of Painting*, London, 1706, p. 459) another expatriate Haarlem painter, Peter Lely, showed Charles II one of his still lifes, which won Roestraten the King's favor. Arnold Houbraken (*De Groote Schouburgh*, vol. 2, 1718, p. 191) claims that Lely did so to avoid competition from another portraitist. Be this as it may, there are three paintings in the British Royal collections by Roestraten that may be the result of royal patronage. Moreover, the present work and several others by the master (e.g. one in the Museo de Arte de Ponce, Puerto Rico, dated 1678) include a medal bearing Charles II's likeness; here it is inscribed: "CAROLUS SECUNDVS D.G.M.C BRI.FRAN.ET.HIB RX." There is no record of Roestraten ever having received a medal from the English king, but other seventeenth-century illusionistic still life painters who received tokens of appreciation from royal and imperial patrons (such as Samuel van Hoogstraten, who was awarded a medal by the Holy Roman Emperor) included them prominently in their displays as an expression of pride and a form of self-promotion.

In the seventeenth century a premium was placed by both painters and their public upon naturalistic likenesses, one of the clearest expressions of which was the illusionistic or *trompe l'oeil* still life. The present tabletop still life assembles various carefully observed precious objects – a carved ivory tankard, a silver cup, a golden statue of St. George, red coral, a ceramic jar with lid, an ivory sculpture of a female figure, golden dish, jewelry box, string of pearls and a ring – on the edge of a table with a reflecting mirror behind and a mirrored sphere overhead. In a time-honored still life tradition, the artist's self-portrait is reflected in the globe, both as a form of signature and to call attention to an unseen world outside the picture frame. Underscoring the artifice of his piece, the artist also includes a painted gold picture frame around the image. Like the mirrored orb, this was a traditional illusionistic device in still life painting, which in this case seeks to obscure the margins or thresholds, as it were, of pictorial and real space and thus heighten the illusion.

In their efforts to optimize their illusionism, artists like Hoogstraten, Cornelis Norbertus and Franciscus Gijsbrechts, who worked for the Danish royal court, painted all manner of *trompe l'oeils*, including windows, painted canvas that seemed to be torn or covered with a curtain, the backs of canvases, wall cabinets, even a cut-out panel in the shape of a painting easel with a still life painting perched on it (Statens Museum for Kunst, Copenhagen). Like the perspective boxes that were popular at this time, all of these efforts catered to an audience that was delighted to be fooled by art; in Hoogstraten's words, "A perfect painting is like a mirror of nature which causes things that are not there to appear, and deceives in an acceptable, amusing and praiseworthy fashion."

Roestraten also painted genre scenes, *vanitas* pieces, still lifes with musical instruments and the occasional landscape. Houbraken praised, above all, his ability to paint silver. He also mentioned that the artist was left partially crippled by the Great Fire of London in 1666.

Jacob van Ruisdael (Haarlem c.1628/29–1682 Haarlem)
Dunes by the Sea, 1648
Signed l.r. *J. Ruisdael*
Oil on panel, 18 x 24 in. (46 x 61 cm)
Collection Suzanne and Norman Hascoe

Provenance: Richter Oelrich, Bremen, c.1820; Bernard Hausmann, Hannover, by 1831; Provinzialmuseum, Hannover; Sale Duke of Cumberland, Berlin (Lepke), March 31, 1925, no. 63, ill.; art market, Düsseldorf, 1948; private collection, Cologne; with delaer Waterman, Amsterdam, 1982.

Literature: C. Hofstede de Groot, *A Catalogue Raisonné*, vol. 4 (1908), no. 925; Jakob Rosenberg, *Jacob van Ruisdael*, (Berlin, 1928), no. 567; Seymour Slive, *Jacob van Ruisdael. A Complete Catalogue of His Paintings, Drawings and Etchings* (New Haven & London, 2001), no. 635, ill.

Jacob van Ruisdael was the greatest and most versatile of all of Holland's famous school of naturalistic landscapists. A productive and infinitely creative artist, he addressed virtually every landscape theme – dunescapes, forests, river views, mountains, waterfalls, beaches, panoramas, winter scenes, marines – and the tenor of his landscapes range from the intimately poetic to the majestically symphonic. He was also a precocious artist. Probably first instructed by his father and possibly also influenced by his uncle, the well known landscapist Salomon van Ruysdael, his earliest dated paintings are fully mature works from 1646, when he was only seventeen or eighteen years old. The present painting is dated two years later, in the same year that he joined the St. Luke's Guild in Haarlem. It is one of a series of early works in which he painted a spit of land with windblown trees clinging to a sandy coast, possibly inspired by the shores of the Zuider Zee southeast of Amsterdam.

Like an earlier work dated 1646, formerly in the Hardie Collection (Slive 2001, no. 627), it depicts a wedge of land crowned with a silhouette of trees and sturdy shrubs retreating diagonally from right to left into the distance beside choppy waters and beneath a windswept sky. However, as

Slive pointed out, "the more transparent and fine filigree treatment of the trees [and] the lighter, more tender palette" of the present painting point to the intervening influence of the landscape painter, Cornelis Vroom, who had introduced these elements into landscape painting almost a decade earlier in Haarlem. The present painting reveals the fact that Vroom's influence upon Ruisdael only began around 1648. Also related to the present work is a highly finished drawing by the artist, dated 1648, of a coastal scene with a view of Muiderberg and the town of Naarden in the British Museum (Slive cat. D80). It, too, reflects Vroom's influence. Although they do not constitute a large portion of his oeuvre, Ruisdael coastal dunes and beach scenes are some of his most beautiful and subtle works and had a lasting influence on these themes in the history of art.

 Rachel Ruysch (Amsterdam 1664–1750 Amsterdam)
Fruit and Flower Still Life on a Marble Ledge, 1683
Signed and dated *R.R. 1683*
Oil on canvas laid down on panel,
21 1/4 x 16 3/4 in. (53.8 x 42.5 cm)
Collection Suzanne and Norman Hascoe

Provenance: Sale London (Christie's), January 12, 1996, no. 96, ill.

Literature: Marianne Berardi, "Science and Art. Rachel Ruysch's Early Development as a Still Life Painter," Ph.D. dissertation, University of Pittsburgh, 1998, pp. 219, 221, 385, pl. 15.

Rachel Ruysch was arguably the best woman painter in the Netherlands during Holland's Golden Age, but she has received relatively less attention than other female artists, such as her earlier Dutch compatriot, Judith Leyster, or the presently fashionable Italian master, Artemisia Gentileschi. Notwithstanding Ruysch's neglect, her life and art deserve greater attention. Born into an exceptionally accomplished family both artistically and scientifically, Ruysch was the granddaughter of the famous architect Pieter Post, the great niece of the first painter of the New World's flora and fauna, Frans Post (who accompanied Johann Maurits to Brazil when he became Governor there), and the daughter of a renowned anatomist, Dr. Frederick Ruysch. Dr. Ruysch not only had an anatomy museum sustained by his secret embalming technique but also helped set up, with the assistance of his daughter, the Amsterdam Botanical Gardens. She, in turn, became the court painter to the Elector Palatine while having nearly a dozen children. Living to the advanced age of eighty-six, she remained active until virtually the end of her life and was the subject of laudatory poems, flattering portraits (see North Carolina Museum of Art, Raleigh) and adoring eulogies.

The present work is a very early piece by the artist, painted in 1683 when she was only nineteen years old and had yet to launch her august, independent career. It depicts a finely observed fruit piece (*fruytstukje*) with green and red grapes, three peaches, a green striped melon, five plums, three butterflies, a snail, a spider and other small insects all assembled on a marble ledge. In her dissertation on the

artist's early works, Marianne Berardi has discussed this painting in relationship to the artist's formation and related it specifically to five other fruit still lifes (Berardi; 1998, plates 14, 16–19) conceived in a similar manner. All of these works acknowledge the precedents established by Ruysch's teacher, the great Delft still life painter Willem van Aelst, who painted fruit still lifes from the 1640s until his death in the year that the present work is dated, 1683. All of the related still lifes are upright in format and feature fruit on a ledge that cuts horizontally across the composition before a dark background with a pyramidal design. The only painting in the group that she suggests may precede the present work is a *Fruit Piece with Oysters and Grapes* in the Musée Granet, Aix-en-Provence. Ruysch would go on to paint more flower pieces than fruit. However, another similarly conceived painting of a *Flower Still Life on a Ledge* dated 1682 was sold at Christie's in London on June 29, 1979, no. 41; compare also the flower still life in the Narodni Gallery, Prague. Berardi posits that Ruysch was active at least as early as c.1680; there are dated works from as early as 1681.

 Cornelis Saftleven (Gorinchem c.1607–1681 Rotterdam)
A Concert of Cats, Owls, a Magpie and a Monkey in a Barn
Oil on panel, 19 x 19 in. (48.2 x 48.2 cm)
Collection Suzanne and Norman Hascoe

Provenance: Marquis of Landsdowne; Sale London (Christie's), July 8, 1994, no. 63, ill.

Literature: Wolfgang Schulz, *Cornelis Saftleven, 1607–1681. Leben und Werke mit einem kritischem Katalog der Gemälde und Zeichnungen* (Berlin/New York, 1978), p. 195, no. 531.

Cornelis Saftleven was both a draftsman and a painter of a wide variety of subjects, including barn interiors with peasants and still life elements, religious subjects, landscapes, animals, portraits, and, perhaps most characteristically, satirical allegories, often with animals, monsters and demons. He was the son and brother of artists of the same name, Herman Saftleven. His brother (1609–1685) also excelled at art and devoted most of his energies to landscape paintings. Although born in Gorinchem, Cornelis spent his youth in Rotterdam before traveling to Antwerp around 1632, where he came under the influence of the famous Flemish peasant painter, David Teniers the Younger. He would return to Rotterdam by 1637 and spent the remainder of his life in that port city.

The present work is characteristic of his delight in satirical and monstrous subjects. Early in his career he painted images of the Temptation of St. Anthony and other religious and allegorical subjects that permitted him to depict witches, demons and monsters in a time-honored tradition that can be traced to medieval art and early Netherlandish artists such as Hieronymus Bosch. Saftleven also painted political allegories, often satirizing contemporary events with companies of animals and other caricatured beasts personifying politicians and clerics (see, for example, *The Trial of Johan van Oldenbarnevelt*, Rijksmuseum, Amsterdam).

The present work depicts a group of animals that had

mostly negative connotations in the seventeenth century. Monkeys, like cats, were regarded as sensual, unreliable creatures given to aping imitation, just like the magpie. The fact that the chorus here is overseen by an owl, while two other owls perch on the wooden partition of the barn at the back right, is not a sign of wisdom as it might be in modern times, but of ignorance; owls are creatures of the night that, when encountered in the day, stagger around like drunks (*Zoo zot als een uyl*, As drunk as an owl, was a popular expression). In the immediate foreground, the fancy finery and pennants some of the creatures sport, the still life objects of cards, dice, a doodlesack (a bagpipe played by fools) and strong drink – all attributes of the tavern and wasted living – further emphasize the animals' corporeal silliness, indulgence and vanity, all of which serve as an admonition to the peasant who peeps in at the back. Saftleven painted at least one other concert of cats (Schulz, 1978, no. 532) and also made a drawing of the subject that has a companion piece of a concert of birds (Rijksprentenkabinet, Amsterdam; Schulz, 1978, no. 250), another theme that often was used for political and theological satires. As Schulz observed (1978, p. 195), the subject of the concert of cats may derive from Jan Brueghel the Elder and certainly has precedents in the art of David Teniers the Elder (Bayerisches Staatsgemäldesammlungen, Munich, no. 920; repr. Adolf Rosenberg, *Teniers der Jüngere*, 1901, p. 97, fig. 79), who, as we noted, was the principal influence on Saftleven.

Georges Seurat (Paris 1859–1891 Paris)
Paysage, l'Ile de la Grande-Jatte (Landscape, Island of La Grande-Jatte). 1884
Oil on canvas, 25 5/8 x 31 1/8 in. (65.1 x 79.1 cm)
Private Collection

Provenance: Inherited from the artist by his brother-in-law, Léon Appert, Paris, 1891–after 1905; Léopold Appert, Paris, 1908–1926; Alex, Reid and Lefevre, Glasgow, 1926; M. Knoedler & Co., London and New York, owned jointly with C. W. Kraushaar Galleries, New York, October 1926; Alex, Reid & Lefevre, London, 1929; Mrs. Chester Beatty, London, 1929–1952; Sir Alfred Chester Beatty, Dublin, 1952–1955; Paul Rosenberg & Co., New York, 1955; John Hay Whitney collection; Sale The Collection of Mr. And Mrs. John Hay Whitney, New York (Sotheby's), May 10, 1999, no. 15, ill.; Stephan A. Wynn, The Bellagio Gallery of Fine Art, Las Vegas.

Exhibited (selected): Paris, Pavillon de la Ville de Paris (Champs Elysées), *Première exposition de la société des artistes indépendants*, 1884–1885, no. 241; New York, American Art Galleries and National Academy of Design, *Works in Oil and Pastel by the Impressionists of Paris*, 1886, no. 112; Chicago, Art Institute of Chicago, and New York, Metropolitan Museum of Art, *Seurat: Paintings and Drawings*, 1958, no. 68; London, The Tate Gallery, *The John Hay Whitney Collection*, 1960-1961, no. 55; Washington, National Gallery of Art, *The John Hay Whitney Collection*, 1983, no. 37; Paris, Galeries Nationales du Grande Palais, and New York, The Metropolitan Museum of Art, *Seurat, 1859–1891*, 1991–92, no. 139.

Literature (selected): Roger Marx, "L'Exposition des Indépendants," *Le Voltaire*, December 10, 1884; J. Le Festec, "Le Salon d'hiver et des indépendants," *Journal des Artistes*, December 13, 1884, p. 2; G. Coquiot, *Seurat*, (Paris, 1924), p. 246; John Rewald, *Georges Seurat* (Paris, 1943), ill. p. 64; John Rewald, *Post-Impressionism – From Van Gogh to Gauguin* (New York, 1956), p. 33; C. M. de Hauke, *Seurat et son oeuvre* (Paris, 1961), no. 131, ill.; Charles Moffett, *The Bellagio Gallery of Fine Art*, ed. Libbey Lumpkin (Las Vegas, 1999), pp. 82–87, ill.

The short-lived Georges Seurat left a permanent mark on the history of modern art with his perfection of the style known as Divisionism or Pointillism. He devised this style as an alternative to mainstream Impressionism, which threatened to dissolve form. Seurat's technique was based in part on color theory and involved covering the white ground of the canvas with countless small points of pure color, which when viewed from a distance blend together as reflected light. In this way he could reproduce in landscapes effects of bright sunlight and deep shade with an unprecedented luminosity. His most famous work is *Un Dimanche à la Grande-Jatte (A Sunday on La Grande-Jatte)* of 1884-1886, now preserved in the Art Institute of Chicago, which depicts crowds of Parisians on a weekend excursion to a narrow little island in the Seine not far from Paris. A very large work with static, carefully composed figures, standing or lying on the grass, it caused a sensation when it was exhibited at the eighth and last Impressionist group show in 1886.

In preparing this major effort, Seurat made numerous conté crayon drawings and painted many small studies on panel of individual aspects of the scene. However, there are only two larger landscape paintings related to the *Grande-Jatte: Étude d'ensemble (Study for "A Sunday on La-Grande Jatte,"* Metropolitan Museum of Art, New York) and the present work, *Landscape, Island of La Grande-Jatte*. It too was undoubtedly begun in 1884 when Seurat made repeated trips to the island. It depicts virtually the same view in almost the same bright sunlit conditions; dark green and blue shadows fill the foreground with shimmering geometric shapes, while the brilliant green grass, beige tree trunks and angled and glittering blue river retreat into the distance. Yet in place of the crowds in *Un Dimanche*, in the present work only a small white dog and a few fishermen populate the scene, suggesting a visit on a workday rather than a Sunday. The relationship and sequence of the various related works are impossible to disentangle; as the Seurat specialist, Robert Herbert, observed in the catalogue of the 1991 exhibition dedicated to Seurat, the larger works could as readily precede as follow the smaller oil studies and drawings. The essential composition is found among the panels and Seurat seems to have worked on it as he went back and forth to the island, making scores of changes and adjustments.

What is clear is that Seurat regarded the present canvas as a finished work of art because he exhibited it twice in his own lifetime, first in Paris in 1884 with the Indépendants, then in New York two years later at the American Art Galleries and the National Academy of Design. According to Herbert, Seurat reworked the picture between the two showings, probably before mid-autumn in 1885, adding small dabs to the shaded and sunlit portions of the grass and the

distant trees. Seurat added subtly contrasting hues, notably the solar orange sprinkled over the shaded grass and the pinks that oppose the bluish purples. The result is a painting of hauntingly beautiful serenity and great richness of surface – truly a resonant ode to the beauty of a summer's day.

 Henri Le Sidaner (Port Louis, Mauritius 1862–1939 Paris)
Landscape with a Table Set in the Garden of the Artist's Home at Gerberoy, 1922
Signed l.l. *Le Sidaner*
Oil on canvas, 23 5/8 x 28 3/4 in. (60 x 73 cm)
Private Collection

Provenance: Galeries George Petit, Paris, no. 10678; Georges Gergaud; Private Collection.

Literature: Yann Farinaux–Le Sidaner, *Le Sidaner. L'Oeuvre peint et grave* (Milan 1989), p. 186, no. 475, ill.

The grandson of a mariner and the son of shipbroker, Le Sidaner was born in Mauritius but he returned with his family to France in 1872, where he grew up in Dunkirk. At the École des Beaux-Arts in Paris, he studied with the academic master Cabanel, before traveling to Italy, Holland and Flanders. During his youth, he responded to the various predominant styles of the day, notably Impressionism, Pointillism and Symbolism – all of which were absorbed and remained permanent features of his art. His early works often feature crepuscular landscapes and town views executed in a free and blurry manner with figures, even crowds, situated in open prospects and cityscapes. But during a stay in Bruges in 1898, he began to reduce the number of the figures in his scenes and entirely eliminated them by c.1900, in a move that acknowledges Symbolism while anticipating Surrealism. The result was an art that echoed with a strangely elegiac tenor and elegant melancholy. In his mature works his touch became firmer and his palette lighter, while he retained his fascination with vacant architecture defining a human presence.

An avid gardener, Le Sidaner purportedly was advised by the sculptor Rodin to consider a country home in the Beauvais area. In 1901 he rented a cottage in the village of Gerberoy and, three years later, acquired an ancient property there that had originally been a medieval fortress. Expanded and extensively renovated over the ensuing thirty-eight years, his summer residence and gardens at Gerberoy became a central subject of Le Sidaner's art throughout the remainder of his career and, indeed, survives today.

Le Sidaner treated the subject of the present work, namely a table set with chairs and the preparations of a light meal in a dappled summer garden without figures, at least a dozen times and more than twenty years earlier, specifically in a painting dated in his first year of residence in Gerberoy, 1901 (formerly Musée Luxembourg, Paris, now Musée Petiet, Limoux; see Farinaux–Le Sidaner 1989, no. 363). He would return to this subject repeatedly in his career, but it seems to have been especially appealing in the period 1921–24 (see as examples, Frainaux–Le Sidaner 1989, nos. 472 & 473) that saw the realization of the present work. The latter is surely one of the most successfully designed and, in

terms of color, one of the most delicately nuanced of the series. While it dates well into the twentieth century, we include it in the earlier half of the *Pleasures of Collecting* exhibition because it constitutes a particularly successful artistic idea that has roots in the late nineteenth century.

 Jan Steen (Leiden 1625/26–1679 Leiden)
Figures Carousing in an Inn
Oil on panel, 21 3/4 x 17 3/4 in. (55.3 x 45.2 cm)
Private Collection

Provenance: Feigneux, Greffier en chef, Cour d'Apel, Brussels; his sale, Paris, November 30, 1812, no. 162; William Henry Fane, 4th Duke of Cleveland (1803–1891), Raby Castle, Durham; thence by descent at Raby Castle, until Sale "The Trustees of the Raby Settled Estate," London (Christie's), November 29, 1974, no. 80 [as unsigned and with the incorrect provenance], to William Drown; Dr. T. Praalder, The Netherlands, by whom offered at Sale New York (Sotheby's), January 8, 1981, no. 69; Sale Amsterdam (Christie's), April 26, 1983, no. 219 [as Circle of Jan Steen, unsigned]; Sale "The Property of a Family Estate," London (Christie's), December 13, 1991, no. 45; Sale, London (Sotheby's), July 6, 2000, no. 69.

Born in Leiden, Jan Steen was the child of a brewer and probably matriculated at the local university before he began his formal artistic education. He is purported to have studied with several diverse masters, including the Utrecht history painter Nicolas Knüpfer, the Haarlem peasant painter Adriaen van Ostade, and the landscapist Jan van Goyen. He joined the Guild in Leiden in 1648, but the following year was in The Hague, where he married his teacher's daughter, Margarethe van Goyen. A peripatetic but not widely traveled artist, he subsequently lived or at least paid dues to the guild in various towns, including Delft, The Hague, Warmond, Haarlem and, once again, Leiden. The facts that his father leased a brewery for him to operate in Delft from 1654 to 1657 and that he applied to Leiden municipal authorities to run an inn in 1672 have been coupled with accounts of his dissolute life and drunkenness by early biographers to confect a life for Steen that has more to do with the subject matter of his paintings than with documented facts. Like his famous sixteenth-century precursor in the painting of comic low-life subjects, the sophisticated humanist Pieter Brueghel, Steen has probably been a victim of the biographical fallacy, namely that his art and his life have been assumed to be the same. In his later career there is evidence that Steen had financial reversals, but he continued to hold offices in the local guild. One of the most talented and original genre painters of the Dutch Golden Age, Steen also painted religious, mythological and historical subjects. His art displays a sophisticated understanding of contemporary Dutch literature and drama.

The present work is typical of the raucous tavern scenes that Steen painted in the tradition of Ostade and Brueghel. The coarse and unbuttoned tavern mistress at the center enjoys a smoke from her pipe as her drunken and libidinous partners cozy up to her. In the background, figures play a noisy game of cards beneath meat curing overhead, while a serving woman tallies the bar bill. A comic moralist who

even inscribed cautionary phrases into some of his tavern scenes in the manner of van de Venne (q.v.), Steen often found ways to admonish his viewers; here the waitress's reckoning reminds us that one pays for one's excesses. Steen often depicted himself in the most dissolute roles in his admonitory tales; the laughing drinker at the center bears some resemblance to the artist. The sly character in the slouch hat is also a model who recurs in Steen's art, which featured a cast of characters whose truth to form is calculated to make us smile.

The painting was not included in C. Hofstede de Groot's *catalogue raisonné* (1908), but the author recorded it as no. 806A in his personal copy of the book preserved in the Rijksbureau voor Kunsthistorisch Documentatie in The Hague. When the picture sold at Christie's in 1974, it was confused with Hofstede de Groot's no. 579 (Karel Braun, *Alle tot nu toebekende schilderijen van Jan Steen*, 1980, no. 131, ill.), which is another tavern scene with a different composition preserved in the National Gallery of Victoria, Melbourne. The doubts about the painting's attribution expressed in the catalogue of the sale in which the picture appeared in 1983 are unfounded and were corrected in the catalogues of the sales in 1991 and 2000; in the latter catalogue the authors purported to be able to see the remnants of a signature ("J…") on a stone at the lower right.

Giorgio Vasari (Arezzo 1511–1574 Florence)
Adoration of the Magi, c.1566
Oil on panel, 25 5/8 x 18 7/8 in. (65 x 48 cm)
Collection Richard L. Feigen, New York

Provenance: Bertha Tilly, New York.

Literature: Giorgio Vasari, *Le Vite de' più eccelenti pittori, scultori et architetti*, (Florence, 1875–85), vol. VII, p. 705; C. Frey, *Der Literarische Nachlass Giorgio Vasaris* (Berlin, 1923–30), vol. II, pp. 262, 879, nn. 324–25.

Giorgio Vasari was a pupil of Andrea del Sarto, Baccio Bandinelli and Rosso Fiorentino before traveling to Rome to work for Cardinal Ippolito de' Medici in 1532. While in the Eternal City, working alongside Salviati, he absorbed the works of Michelangelo and Raphael, as well as those of the latter's followers. Traveling widely throughout Italy from the late 1530s onwards, he not only executed numerous artistic commissions but also compiled notes for his famous book on the lives of the artists (*Vite de' più eccelenti pittori, scultori et architetti*, 1550 and an expanded edition 1568). Entering the service of Cosimo de' Medici in Florence in 1554, he designed and oversaw the decorations with assistants of the Palazzo Vecchio between 1555 and 1572. He was working on a fresco of the Last Judgement for the cupola of the Duomo in Florence at his death in 1574. Although Vasari is often regarded today as more famous for his writings than his art, he was the leading proponent of the high *maniera* in the mid-sixteenth century and codified the official style in the Florentine court of Cosimo de' Medici.

The *Adoration of the Magi* is a *modello* for Vasari's altarpiece in the Church of Santa Croce in Bosco Marengo. As Vasari explained in the autobiographical chapter of the second edition of the *Lives* (p. 705), it was commissioned by Pope Pius V in 1566 for the church in his hometown. Vasari

mentions a preparatory piece on panel (*tavola*), which no doubt is the present work, that was to be presented to the Pope for his approval of the design. There also is a pen and ink preparatory drawing for the composition in the Uffizi, Florence (inv. no. 1191E). The massive yet decorative forms of the figures and the boldly contrasted color scheme are characteristic of the high *maniera*. Vasari conceived the Adoration here as a highly formalized, hierarchical event. He employs a tightly organized triangular composition with the Madonna and Child enthroned at the apex of the adoring Magi and onlookers arrayed to the right and left, almost as in a traditional Sacra Conversazione, and beneath a hovering canopy of putti. We know from a letter dated July 1566 to Vasari from a papal official, Guglielmo Sangaletti, that the Pope observed of the artist's work "that the Virgin Mary was not in a palace when she brought forth the Savior, as it is depicted by you, but in a hovel." However, Vasari retained his original conception in the final altarpiece.

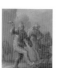

Adriaen van de Venne (Delft 1589–1662 The Hague)
Weeldigh Gebreck (Luxurious Injury), 1634
Signed and dated *1634*
Panel, grisaille 13 3/4 x 11 3/4 in. (35.5 x 30 cm)
Private Collection

Provenance: O. Bremmer; with dealer D.A. Hoogendijk; Sale Amsterdam (Mak van Waay), November 18, 1975, no. 211.

Literature: L.J. Bol, "'Een Middelburgse Brueghelgroep,' VIII. Adriaen van de Venne, schilder en teyckenaer," *Oud Holland*, vol. 73 (1958), p. 142, note 38; A. Plokker, *Adriaen Pietersz. Van de Venne (1589–1662). De grisailles met spreukbanden*, in *Leuvense Studiën en teksuitgaven*, New Series, no. 6 (Louvain, 1984), pp. 236–237, cat. no. 99, ill.

Both a painter and a poet, Adriaen van de Venne was born to Flemish émigré parents in Delft. He studied first with a goldsmith before becoming a pupil in The Hague of Hieronymus van Diest – a painter in grisaille, or monochrome, which van de Venne would eventually adopt as one of his specialties. After a possible trip to Antwerp, van de Venne settled in Middelburg where he was active until 1625. During this period he painted mythological and historical subjects as well as a few grisailles, but most notably painted landscapes in color in the tradition of Jan Brueghel the Elder, contributing to the rise of a new indigenous naturalistic landscape tradition in the Netherlands. During these years he also provided illustrations for the writings of the moralizing poets Jacob Cats and Johan de Brune, some of which were published by his brother Jan, who had a printing shop in Middelburg. Van de Venne registered in the guild in The Hague in 1625 and spent the remainder of his life there working as an illustrator and painter. He even enjoyed the occasional patronage of the Princes of Orange and the King of Denmark.

A large portion of van de Venne's production is comprised of images of peasants and low-life figures painted in grisaille or brunaille and often appended with inscriptions or sayings

on banderoles. Confident and clear in design, they are executed with a fine eye for caricature and a spirited touch in tones of gray or brown with deftly applied white highlights. These works descend from the peasant painting tradition of Pieter Bruegel the Elder and share features with the works of Adriaen Brouwer and Adriaen van Ostade. Yet while the last mentioned usually depicted the working poor, van de Venne painted truly marginalized social figures – beggars, cripples, mendicants, vagrants and prostitutes. In its concentration on the underclass, his art shares something with the early graphic work of Rembrandt, but van de Venne's inscriptions offer a direct commentary on his subjects. These are usually humorous and satirical but sometimes sympathetic as well.

The present work depicts a decrepit peasant couple, she with her arm in a sling and he wearing a spoon in his hat and twirling an empty supper dish, as they dance crudely to the ear-piercing strains of a young rommelpot player at the back right and a one-legged hurdy-gurdy player at the back left. Van de Venne often depicted dancing couples. For example, he made a very similar image (Plokker, 1984, no. 15, ill.) of a tattered old peasant couple dancing, but in which the man has a crutch and only one leg and the woman gaily raises the bowl, under a banderole with the words *Arme Weelde* (Poor Luxury). In the Museum of Fine Arts in Springfield, MA, there also is an image of a dancing peasant couple, she with the bowl and a basket on her head, he with the hurdy-gurdy, but with the ominous appearance of the skeleton of Death behind, and the inscription, *Weeldighe Armoede* (Luxurious Poverty). That painting has a companion piece (also in Springfield) depicting a couple with a richly dressed woman (probably a prostitute) and a crippled beggar about to be attacked by Death, with the inscription *Ellendige Weelde* (Wretched Luxury) (see Plokker, 1984, nos. 98 and 37). While Plokker would not venture an interpretation of the inscription on the present work, which reads *Weeldigh Gebreck* (Luxurious Injury), she linked it to these two other images as a probable admonition against the foolish heedlessness of the underclasses and the pastimes of the indigent.

Simon de Vlieger (Rotterdam c.1601–1653 Weesp)
Beach Scene with Fishermen and Other Figures on the Shore, Shipping Beyond, c.1643–45
Oil on panel, 18 1/4 x 26 in. (46.3 x 66 cm)
Private Collection

Provenance: Davidson collection, London; with Colnaghi's, London; Marcus Kappel; his Sale, Berlin Cassirer & Helbing, Berlin, November 25, 1930, no. 24; Louis and Mildred Kaplan, New York, by 1950; Dr. C.H. Muntz, Wassenaar, by 1975; with K. and V. Waterman Galleries, Amsterdam; with Bob Haboldt & Co., New York; Private Collector, West Coast; Sale New York (Christie's), January 2001, no. 50, ill.

Literature: W. von Bode, *De Gemäldesammlung Marcus Kappel in Berlin* (Berlin, 1914), p. 24, no. 35; W. von Bode, *Die Meister der Holländischen und Vlamischen Malerschulen* (Leipzig, 1917), p. 252; W. R. Valentiner and

D.P. Wescher, *A Catalogue of the Paintings in the Collection of Louis and Mildred Kaplan* (1950), fig. 22; L. J. Bol, *Die Holländische Marinemalerei des 17. Jahrhunderts,* (Braunschweig, 1973), p. 184, fig. 186.

A versatile artist, Simon de Vlieger painted and drew seascapes, beach scenes and landscapes as well as a few genre scenes and portraits. He also enjoyed official patronage, creating decorations for Maria de' Medici's entry into Amsterdam in 1638, painting organ doors for Grote Kerk in Rotterdam in 1645, and received the lucrative commission to decorate the windows on the south side of the Nieuwe Kerk in Amsterdam in 1648. Today he is best remembered for his subtle marine and atmospheric beach scenes. His early works (the earliest dated work is of 1624) owe a strong debt to the influential "tonal" seascapist, Jan Porcellis, and often depict ships off coasts with fantastic rock formations. However, around 1630 he began to paint more naturalistic beach scenes with calm seas and tranquil skies (the earliest, dated 1633, was formerly in Capt. Eric Palmer's collection; see National Maritime Museum, Greenwich, England, exh. cat. 1962, no. 40) and he had fully developed the theme by the early forties. The leading authority on de Vlieger, Jan Kelch, dates the present work c.1643-45 and compares it to the famous example dated 1643 in the Mauritshuis, The Hague, and the beach scene in the Wallraf-Richartz Museum, Cologne. Like the present work, these paintings are prized for their sweeping panoramic effects, bright but subtly overcast tonalities, and evocation of the moist and silvery air of the beach. His works of this period parallel those of Jan van Goyen in their understated, "tonal" palette of grays and browns with hints of blue and yellow, but also presage his works of the 1650s that reintroduced greater color and a more luminous tonality. De Vlieger also often featured a darkened band of shadow in the foreground, as seen here, that serves with the silhouetted figures on the beach to enhance the sense of spatial recession. De Vlieger recorded his figures in drawings and prints, many of which have survived. After 1650, de Vlieger painted mostly coastal marines with calm seas and a few forest scenes. He is regarded as one of the most important marine painters of Holland's Golden Age.

The beach theme finds its roots in Dutch art in Hendrick Goltzius's images of beached whales (then believed to be bad portents) and developed into the bustling images of the strand with many colorful fisherfolk, vessels and seamen by Adam Willaerts. Drawing on the influence of Porcellis, de Vlieger was instrumental in shifting the emphasis in beach scenes from the figures and shipping to the weather and atmosphere, beautifully evoked with soft, vaporous veils of muted color. He, in turn, influenced later devotees of the beach scene, such as Jan van de Cappelle and Jacob van Ruisdael (q. v.). A final iteration of the beach scene in Dutch art were Adriaen van de Velde's works, painted between 1658 and 1670, but these, unlike de Vlieger's, favored bright sunshine and close-up views of the figures.

George Frederic Watts (London 1817–1904 London)
Portrait of Lady Lindsay Playing the Violin, 1876–77
Oil on canvas, 43 1/2 x 33 1/2 in.

(109.9 x 85.1 cm)
Private Collection

Exhibited: London, *Inaugural Exhibition*, Grosvenor Gallery, 1877; New Haven, Yale Center for British Art, *The Grosvenor Gallery. A Palace of Art in Victorian England* (ed. By Susan P. Casteras and Colleen Denney), (also shown at the Denver Museum of Art, and the Laing Art Gallery, Newcastle upon Tyne, 1996) pp. 114, 118, 199, cat. no. 64, pl. 24.

George Frederic Watts was one of the most distinguished portraitists and history painters of the later Victorian era in England. Born in London, he studied with the sculptor William Behnes and exhibited at the Royal Academy as early as 1837. He visited Paris and Italy c.1843-47 and soon won the patronage of aristocratic collectors. He made a reputation for himself painting historical subjects and allegorical themes, as well as social commentaries on such themes as the Irish famine. Watts was also active as a landscapist and sculptor. Allied to the Aesthetic Movement of the 1860s, which celebrated "art for art's sake," he spoke of his "painted poems" and aspired to paint "symbolical" paintings. At the same time, he was generally regarded as one of the most distinguished portraitists in England.

The present work depicts Blanche, Lady Lindsay, a Rothschild descendant, who together with her husband, Sir Coutts Lindsay, were important patrons of Watts and founded the Grosvenor Gallery, where Watts exhibited many of his most important paintings. The Lindsays entertained their guests in their homes at Cromwell Place, South Kensington, and at Balcarres, Scotland, and moved in influential artistic circles. Conceived as an alternative to the Royal Academy, with which artists after c.1860 had become increasingly disenchanted because of its space, installations and selection processes, the Grosvenor Gallery not only featured Watts but also leading artists like Edward Burne-Jones and James McNeill Whistler, as well as members of the second generation of the Pre-Raphaelites. The present work depicts Lady Lindsay in her early thirties, captured momentarily in a daring, three-quarter length pose. She has turned away from the viewer but looks back over her shoulder to meet our gaze as she plays the violin. She wears a striking, olive-green dress gathered at the back in a bustle and is placed before a painting of angels and a pilaster. It was one of four paintings that Watts sent to the inaugural exhibition of the Grosvenor Gallery in 1877. He also showed his great allegorical composition, *Love and Death* (The Whitworth Art Gallery, University of Manchester), and his portraits of Edward Burne-Jones (Birmingham Museum and Art Gallery) and The Hon. Mrs. Percy Wyndham (private collection). This was the same exhibition in which Whistler's *Falling Rocket* ignited such a controversy. No less distinguished reviewers than Oscar Wilde and the expatriate Henry James critiqued the show, the latter characterizing Watts as "the first portrait painter in England," who also had a "great longing to deal with 'subjects'," as in *Love and Death*, which James went on to praise.

 Jan Baptist Weenix (Amsterdam 1621–c.1660 Utrecht)
Customers with a Vegetable Merchant, 1656
Signed and dated l.l. *Ao 1656 Gio. Batta. Weenix f.*
Oil on canvas, 30 3/4 x 26 1/4 in. (79 x 68 cm)
Collection Suzanne and Norman Hascoe

Provenance: Sale J.J. de Bruyn, Amsterdam, September 12, 1798, no 33 [as Metsu]; to Yver; Duc de Broglie, Paris [as Metsu], Colonel W.A. Hankey, Beaulieu, Hastings; Iwan Gans; with Sedelmeyer Gallery, Paris; with dealer Katz, Berlin, 1930; Recuperated after WWII, Munich, c.1946; Dr. Leo Coccia, Rome, 1954; H. Girardet Collection, Kettwig (Ruhr).

Exhibited: Cologne, Wallraf-Richartz-Museum, *Sammlung Herbert Girardet. Holländische und Flämische Meister* (also shown at the Museum Boymans-van Beuningen, Rotterdam) 1970, no. 64.

Literature: W. von Bode (reissued and edited by E. Plietzsch), *Die Meister des XVII. Jahrhunderts* (Leipzig, 1960), p. 139; E. Plietzsch, *Meisterwerke der holländischen Genre-Malerei des 17. Jahrhunderts* (Essen, 1962), pl. 3; Rebecca Jean Ginnings, "The Art of Jan Baptist Weenix and Jan Weenix," dissertation, University of Delaware, 1970, p. 178, cat 62, fig. 69.

Jan Baptist Weenix was one of the most accomplished of the legions of Dutch painters who turned their artistic attentions not to the cool and monochromatic landscapes of their homeland but to the sunnier climes of Italy. Taught in the North, originally by Abraham Bloemaert and Claes Moeyaert, he followed the prescription of Dutch art theorists and completed his artistic education with a stay in Italy that lasted four years. His familiarity with the Italian *campagna* and the outskirts of Rome, with its striking landscape, classical ruins and picturesque inhabitants served him well for the rest of his artistic career. Indeed, the present work, like many of his Italianate scenes, was executed long after he had returned from Italy in 1647. It depicts an itinerant and seemingly nonchalant greengrocer peddling his produce to assembled customers from a wheelbarrow in which he reclines. A large brass milk can offers a fine still life in the foreground. The scene is dappled with light but mostly cast in shade by a large archway with classical proportions. The compositional device of the darkened archway enhances the sense of relief in the picture as well as the recession of the landscape beyond. The subject of peddlers and the common citizens of Rome moving about in the grand streets of the eternal city had been popularized by Pieter van Laer (Bamboccio) and his followers. However, Weenix lightened the tonality and added more color than did his predecessors among the Dutch Italianates who specialized in street scenes.

The present painting was misattributed as early as 1798 to Gabriel Metsu (who was a darling of the eighteenth century), apparently because of a false signature (reported as late as 1907) and the superficial resemblance to that artist's graceful and colorful manner. However, the work was recognized as a J.B. Weenix by the Parisian Gallery Sedelmeyer in 1900 and fully accords with his style from the late 1650s. The lat-

ter featured elegantly posed and colorfully dressed but not socially elevated figures, who are large in scale relative to the staffage of his early compositions. They are also often depicted in a setting with bright sunlight and shade, creating dramatic spatial effects. Compare, for example, the *Woman Sleeping and Other Figures beneath Ruins with an Archway* in the Alte Pinakothek, Munich, and *The Tinker* in Viscount Allendale's Collection, Stockfield, both of which are also dated 1656.

 Adriaen van der Werff (Kralingen 1659–1722 Rotterdam)
An Elegant Couple Making Music in an Interior
Oil on canvas, 19 x 14 in. (48 x 35.5 cm)
Private Collection

Provenance: Hendrik Schut; his sale, Rotterdam, 8 April 1739, no. 1 (305 florins); G. Th. A.M. van Brienen van de Grootelindt, The Hague; his sale, Paris, 8 May 1865, no. 47 (2,600 francs to Say); Emma Budge, Hamburg; her sale, Berlin (Graupe) 4 October 1937, no. 6 (as Caspar Netscher); Eugene L. Garbaty, Schloss Alt-Doebern, Niederlausitz, the Shore Haven, Connecticut, until 1946; Bree and van Groot, The Hague, 1958; Leger Galleries, London, 1958; Aquavella Gallery, New York; Rudolf van Fluegge, New York; his sale, William Doyle & Co., New York, 1983; Richard Green Gallery, London, 1984; Private Collection, Washington, D.C., U.S.A.; purchased from Johnny van Haeften, London.

Literature: John Smith, *Catalogue Raisonné* (1833), no. 103; C. Hofstede de Groot, *Catalogue Raisonné* (1928), no. 164 [as Caspar Netscher]; Barbara Gaehtgens, *Adriaen van der Werff 1659–1722* (Munich, 1987), pp. 203–205, cat. no. 9, ill., color pl. I.

The son of a miller, Adriaen van der Werff was apprenticed in Rotterdam to Eglon van der Neer, who was specifically contracted to instruct him in the *fijnschilder* technique practiced by the Leiden circle of artists around Gerard Dou and Frans van Mieris (qv). Although misattributed in the past to Caspar Netscher as well as to Eglon van der Neer, the present work is undoubtedly a relatively early work by van der Werff; it reflects his teacher's style in the detailed treatment and colorful palette of the lavish costumes and the emphasis on the elegance and sumptuousness of the scene. In attaining this elegance, the figures are more studied in the grace of their movements and more generalized in their features than in earlier works by the *fijnschilders*. Also, van der Werff's manner is more fluid than the hard, enameled touch of his teacher. The author of the monograph on van der Werff, Barbara Gaehtgens, dates the work to about 1678, and notes its close resemblance to van der Neer's *Woman Playing a Lute* in the Statens Museum, Copenhagen, and the *Woman Tuning a Lute*, dated 1678, in the Alte Pinakothek, Munich. The smiling man with the curled tresses, seated and holding the viola da gamba, resembles his counterpart in Adriaen van der Werff's *Young Artist in an Atelier* in the Hermitage, St. Petersburg.

Van der Werff's stylistic development seems to reflect social trends in the Netherlands. Even before Louis XIV's troups invaded Holland in 1672 (the disastrous *Rampjaar,*

which for all intents and purposes rang down the curtain on the Dutch Golden Age), the upper classes had begun to adopt French fashions and tastes. While van der Werff's earliest dated genre scenes (see *Youth with a Mouse Trap*, dated 1676, Private Collection; Gaehtgens cat. 1) align themselves with the Leiden *fijnschilder* traditions of depicting comical figures in niches he quickly adopted the elegant manner of depicting the musical and merry companies of richly dressed, high-born folk popularized by Gerard ter Borch and his followers and sought after by the new collectors. In his later years van der Werff painted mostly religious and mythological scenes, in a smooth, classical manner that clearly met with his aristocratic patrons' tastes. Hailed by Arnold Houbraken (1718) as the greatest painter of the age, he became court painter to the Elector Palatine and was even knighted in 1703, thereafter signing his pictures "Chevalier."

Credits

This catalogue is published in conjunction with the exhibition
Pleasures of Collecting: Part I, Renaissance to Impressionist Masterpieces,
organized by the Bruce Museum of Arts and Science, Greenwich, Connecticut,
September 21, 2002 through January 5, 2003.

ISBN 0-9720736-3-9

Printed in the United States of America by Totalgraphics, Inc., Norwalk,
Connecticut.

Catalogue design: Anne von Stuelpnagel
Editing: Martha Zoubek, Susan Larkin
Proofreading: Joan Antell

Photography:
Photographs of works of art reproduced in this volume have been provided
in many cases by the owners or custodians of the works, identified in the
checklist. Individual works of art appearing herein may be protected by
copyright in the United States of America or elsewhere, and may thus not be
reproduced in any form without the permission of the copyright owners. The
following and/or other photograph credits appear at the request of the artists'
representatives and/or owners of individual works.

Paul Mutino:
pp. 17, 18, 19, 32, 36, 39, 40, 47, 48 (top and bottom), 49, 50, 52, 53, 54, 55,
59, 62, 63, 64, 65

Prudence Cuming Associates Limited:
pp. 30, 31

Bruce M. White:
p. 12

Cover:
Georges Seurat (Paris 1859–1891 Paris)
Paysage, l'Ile de la Grande-Jatte (Landscape, Island of La Grande-Jatte), 1884
(detail)
Oil on canvas
25 5/8 x 31 1/8 in. (65.1 x 79.1 cm)
Private Collection